Build Your Own Independent Nation

Copyright © 2012 by Kyōhei Sakaguchi
Translation copyright © 2016 by Corey Turpin
Translation copyright © 2016 by Kazuaki Egashira
Published 2016 by Doyosha
11-20-301 Sarugaku
Shibuya Tokyo
Japan
All rights reserved

Build Your Own Independent Nation / Kyōhei Sakaguchi
ISBN 978-4-907511-24-1
Printed in the United States

First published in Japan by Kodansha, 2012

Cover design by Noriteru Minezaki

Cover drawing:
Dig-ital by Kyōhei Sakaguchi, 2006
courtesy of Mori Yu Gallery

Dear English readers,

This is the first time that a book I have written has been translated into English, and I would like to give a brief self introduction.

I originally aimed to be an architect, because ever since I was little I was always interested in creating spaces that I could enjoy. My wish however was to build a "nest" rather than a "house." In fact, nests of creatures like birds, antlions and even bagworms seemed to resonate better within me. To put it in human terms, structures like vacant run-down houses or junk-filled sheds more closely resembled my idea of a "human nest."

Daydreaming of such things, my architectural studies soon became a difficult path to continue. An architect's job, first of all, is to receive requests to design houses for others. I had no intention of designing other people's houses. Furthermore, when I was a freshman university student in my architecture department, nearly twenty years ago, there already were over five million vacant houses throughout Japan, adding to my conviction that there was no need, nor point, in building even more.

However, my professors and friends would tell me that I wouldn't be able to "make a living." In other words, professional architects build houses for money. What a contrast from other living creatures! I wanted to become a "nest craftsman" rather than an "architect." In addition, the act of "owning land"—a human behavior considered perfectly normal in postmodern Japan—seemed nothing more than a ridiculous delusion. But apparently you can't survive in today's world having these thoughts.

It was then, that the street dwellers of Tokyo, the so-called "homeless", enlightened me with their wisdom. Mr. Suzuki Shōzō residing by the Sumida River and Mr. Funakoshi Yasuo by the Tama River, in particular, gave me the most suggestions.

Of their own accord, they chose to live on the streets, without owning land, actualizing their houses built for surviving—"human nests" in other words—without any money, in none other than Tokyo, where land prices

are ridiculously high. I called them "Urban hunter-gatherers" and made visits daily, learning that reality was not a singular concept, that in fact uncountable numbers of layers are present to exist in. This book weaves the wisdom I was able to collect there together with some of the answers to my questions I've had since childhood.

Later on, I took further action.

On March 11th, 2011, the Great East Japan Earthquake occurred off the coast of Sanriku, rocking the nation with a magnitude of 9.0. When I turned on the television, I saw coastal houses of the north-east being swept away by the tsunami. On the following day, reactor Unit 1 of the Fukushima Dai'ichi nuclear power plant exploded, spewing enormous amounts of radioactive material into the air. Yet, the official government insisted on stating that "it does not pose immediate health risks, as for now." While the severity of the matter seemed to be ignored, it was no ordinary sweat running down the Chief Cabinet Secretary's forehead. Visceral human reactions do not lie. Watching the television screen, I sensed that something horrific had happened. I decided to take my family, leave behind my 15 years of living in Tokyo and flee to my hometown in Kumamoto, Kyūshū.

Oddly enough, my internet TV broadcast at the time, Lifestyles of Urban Hunters and Gatherers, happened to do a show on nuclear power plants just one week prior to the earthquake on March 3rd. The specialists I invited that day expressed their concerns toward the aged and deteriorating structures of Fukushima Dai'ichi plant, warning viewers that a power source failure was more likely to occur due to a tsunami, rather than an earthquake. For this reason I must have taken the accident more as a personal issue, rather than simply a natural or human disaster. While the official government repeatedly proclaimed there was "no problem," I meditated alone on what I could do, witnessing the fear and anxiety that people shared over the internet.

My two street dwelling masters had created their own reality from zero, without complaining nor seeking help, by recognizing that this world consists of countless layers. It was time for me to put that wisdom into practice. And so, on May 10th, 2011, I founded my "New Government," and inaugurated myself as its first Prime Minister. Fed up with the overwhelming 30,000+ suicides recorded annually in Japan, I also publicly released my personal mobile phone number as a suicide prevention hotline. I cannot remember a time in my life when I was more concerned about "survival." This book stands also as a testament to my actions during this

period. As I write these words today in 2016, my new government heads into its 6th year since independence with a constituency of over 48,000.

What I want to express, fundamentally, is "how we can create a world where dying is not considered an option."

I'd be delighted if my readers could sense that this multi-layered world cannot be limited to the singular reality in which we are made to believe that survival requires money, and that it is in fact filled with countless forms of making a living.

I have come to publish seventeen books in Japanese so far. I hope this leads to the translation of other books of mine, allowing people from all walks of life to read them.

I thank you all very much for picking up this book.

February 5th, 2016 Kyōhei Sakaguchi

Preface

Nice to meet you, I'm Kyōhei Sakaguchi.//
To this day, I'm still not quite sure what my "profession" is. So I always say to those who ask, "What do I appear to you as? Whatever your answer may be, that's my profession." Even so, the *works* that I do are very clear to me.

I was born in Kumamoto Prefecture in 1978, which makes me 34 years old. I have a wife and a three-year-old daughter. I have an apprentice by the name of Yoné. I live in a 70 m², 3DK* apartment in Kumamoto city. Monthly rent, 60,000 yen†. Also I have an office right across the road from the house where the novelist Sōseki Natsume used to live when he was an English teacher at what is now Kumamoto University. This office is a traditional Japanese structure, about eighty years old, standing on 200 m² of land. My apprentice and I renovated it at a cost of 150,000 yen. I currently rent it for 30,000 yen per month, which is quite an exceptional deal.

My income in 2011 was approximately 10 million yen. I have about 3 million in my bank account.

After graduating from high school in Kumamoto, I moved to Tokyo to study architecture at Waseda University. I studied under an architect by the name of Osamu Ishiyama. For a single year following my graduation, I slid into Dr. Ishiyama's architectural research lab for "zero yen", and since then I've been working independently.

Despite having a degree in architecture I have yet to construct anything that is certified under current Japanese law as actual architecture. The few structures I have built resemble children's playhouses. Therefore, under Japanese law, I'd be considered an architect who doesn't build. I don't even hold an architect license. I've simply never felt the need for it with the works that I do.

I researched the homes of street dwellers for my graduation thesis. Despaired at the almost total commercialization of today's architecture,

* 3DK in Japanese real estate terms indicates that there are three rooms in addition to a dining room separated from the kitchen; a standard format for apartment housings in Japan.//
† One U.S. dollar roughly equaled 80 yen in 2012, the year this book was written. ¥60,000 = $750

and wanting to design houses that existed more in the way that a bird's nest does, their homes were my only light of hope. That graduation thesis became a photo-book in 2004, called *Zero Yen Houses*. Therefore, technically, I began my professional career as a photographer. Since the book did not sell in Japan, I immediately took it to Europe and North America, and from 2005 I started working in the world of contemporary art. In 2006 I held my first solo exhibition at the Vancouver Art Gallery in Canada and became known as a contemporary artist there. My main source of income since then has come from my patrons purchasing my artwork.

In 2008 I started my writing career in Japan. I utilize language to convey what homes mean to me as an architect who doesn't build. I have written four books, two paperbacks, and one of my books has been translated into Korean. I have published eight books so far, if I include my photographic works. Therefore, you could also consider me a writer.

Other than that, about three to four times a month, I give talks. The easiest way for me to convey my thoughts to people is by talking. I also give many lectures at universities. Since many of my stories aren't too serious, and tend to be rather comical, you could even call me a comedian. In fact I also perform *Rakugo**. I sometimes even perform as an opening act for Master Yanagiya Sanza. Therefore, I am also a *Rakugo-ka*, a Rakugo professional.

In addition, I can sing songs while playing guitar. I can make about 10,000 yen per day on the streets. I fed myself throughout my university years by doing so. I even have a few albums released, although of course they're all on independent (indie) labels. This alone allows me to make a living. Therefore, you could also call me a musician.

From the summer of 2012, for three months, I am going to be working in Europe. The people who have invited me are all directors of plays and performances. They see me as an actor, acting out my daily life. So from this European perspective, I am also a performing actor.

On top of that, in recent years, I've been building houses on wheels called "Mobile Houses." Under Japanese law, these don't qualify as houses because of the wheels. When I gave a lecture in Singapore, where rent is skyrocketing due to an economic bubble, audience members perceived me in all their seriousness as an architect. Therefore apparently, you may call me an architect as well.

And last but not least, I am the Prime Minister of a "New Government"

* Rakugo is a traditional style of Japanese comedy with its roots dating back to the 9th and the 10th century. The art form gained popularity as a phenomenon in the Edo period (1603-1867).

that I have founded. You probably have no clue as to what I'm talking about, so I will explain little by little in this book.

Yes, I have founded an independent nation.

I construct my life with just my own hands, without belonging to any social faction. That's the kind of human being I am.

Why did my life turn out this way?

There is a reason.

It's because nobody has been able to answer the questions that I've had since I was little. That's why I have founded an independent nation—and I'm still in the process of finding answers for these questions myself.

I'd like to list my questions below. How would you answer them? I'd be honored if you could read this book with these thoughts in mind.

The kinds of questions that Kyōhei Sakaguchi has kept asking since he was little...

1. Why is it that only humans cannot live without money? Besides, is it even true?

2. We pay rent every month. But why does it go to a landlord and not the land itself?

3. Most household electronics can run on just a car battery. So why do we need such vast amounts of electricity that require us to build things like nuclear power plants?

4. It is clearly stated in Japanese real estate law (the Basic Act for Land) that you cannot buy or sell land for investment purposes. So why aren't real estate companies prosecuted?

5. What we call money here is a bank bond that the Bank of Japan issues. Yet why do some people at times even cry for joy when they receive these bank bonds?

6. Why do we think that we humans will die without money, when we have biwa* and orange trees growing in our garden?

7. If the government of Japan was protecting the people's right to

* Biwa is Japanese for loquat, an indigenous Japanese fruit.

survival guaranteed by the constitution, then there should be zero homelessness. Why are there so many living on the streets, with their rights to build even a little shack taken away from them?

8. In the year 2008, 13.1% of houses in Japan stood abandoned. And according to a Nomura Research Institute forecast, that figure is going to rise to 43% by 2040. Yet why are houses being continuously built at such a rapid rate?

How would you answer if your children asked you these questions?
And now, this brings us to consider how to build an Independent Nation.
Lights down! Curtain!

CONTENTS

Dear English readers — 3
Preface — 7
Prologue: The Adventure in the Storm Drain — 13

CHAPTER 1 Countless Layers Already Exist
1. The Layered Lives of Street Dwellers — 19
2. Putting Wheels on Homes—Mobile House — 30
3. March 11th, 2011 — 38

CHAPTER 2 Between Private and Public
1. Who Does Land Belong to? — 41
2. A "Public" that Comes Seeping Through — 49
3. May 10th, 2011, The Birth of a New Government — 53

CHAPTER 3 Trade by Expression, With Attitude Your Currency
1. A New Form of Economy — 61
2. Two Worlds Called School Society and After-School Society — 71
3. My Attitude Economy Documented — 80

CHAPTER 4 Methodology for Creative Works,
 a.k.a. the Human Machine Theory
1. The Definition of Creative Works — 97
2. Think of Yourself as a Machine — 102
3. How to Use the Lens of Despair — 108

FINAL CHAPTER And Now, to the Zero Yen Revolution — 115

Epilogue: We are Not Alone — 127
Post Script — 129

PROLOGUE

The Adventure in the Storm Drain

I'd like to begin by talking about some adventures that I went on when I was a first grader in elementary school.
Though they were fun and exciting, I doubt anybody even noticed them. My best friend Taka and I often used to go on these adventures together. And I feel as if our adventures have never really ended for me.
So I think I'll start this book by telling you about our experience.

I lived in a town called Shingū in those days, in the Kasuya district of Fukuoka Prefecture. It was a coastal town on the island of Kyūshū overlooking the Genkai-nada Sea.
I was living in a company residence complex built by Nippon Telegraph and Telephone Public Corporation (present day NTT*), my father's employer. It was quite a big corporate housing unit among about forty similar buildings lined up in a row. When I was little, I could pretty much live without ever leaving this local area. In my mind, it was a world of its own.
But around the time I entered elementary school, I started to become aware that there were other worlds outside. I used to go play in many different places with Taka, who also lived in one of the company homes. And when I made new friends at my elementary school, I started to realize that different people lived in all sorts of places.
The ones living in the company units were from the middle class, who had no connection with the area of Shingū originally, but were there, in most cases, as a result of their father's job transfer.
Walking towards the ocean from my house you would come to a small and dirty river. Crossing the bridge over the river and continuing through a railroad crossing would lead you to a street lined on both sides by pine trees. If you kept going, then the asphalt road would eventually turn into a sandy track, and after you passed through a small pine forest the Genkai-nada Sea would come into view.

* Nippon Telegraph and Telephone Corporation commonly known as NTT, a Japanese telecommunications company originally established as a government owned cooperation in 1952. It is the largest telecommunications company in the world in terms of revenue.

If I were to walk slightly to the west without walking all the way to the ocean, then an old settlement would appear, a shift from the mundane view of the company housing. There were shrines that remained from the old days. Unlike in the nuclear family structure common in the company homes, many of my classmates from this area lived with their grandmas and grandpas. There were many small streets that cars couldn't even drive through, making it an ideal space for us kids to run around freely.

If I were to walk to the east, then a group of very nice new houses would appear. They had been constructed by Sekisui House Co., Ltd*. Each one was very neatly built, and they were separated from each other by big gardens and brick walls.

A girl that I liked at the time also lived there. I visited her house once, with its open and spacious living room and nicely trimmed lawn, and of course she had her own room all to herself. At the time, this house was my dream space.

So like this, I started to vaguely think about how my friends all lived in different places, and how the differences in the people were reflected in the shapes of their houses, family structures, even the smell of the land was slightly different.

Meanwhile, I felt that the Genkai-nada Sea always accepted me, regardless of the color and the feeling of the land I lived on.

Therefore, I felt most relaxed when I was at the ocean.

I would get lost in time in the pine forest and I once discovered an antlion in the sand which had built a shelter and was waiting for an ant. I remember getting excited, thinking "Wow! This is an antlion's house!"

I came to realize that my favorite houses were those that insects built on natural land.

At the same time, I couldn't really come to like the company residence I lived in.

It seemed as though it wasn't really the place I was supposed to live.

But I had my best friend there. That was a happy thought. So I tried to accept the fact that I lived in a company home, because it wasn't the house that I lived in that mattered. It was more about the people.

It was in this context that Taka and I started creating our own ways to have fun, through much trial and error, all from scratch.

The first activity we did was hopping around on pogo sticks, which were popular back then. We would bounce around on roads, the grassy areas,

* Established in 1960, Sekisui House is one of Japan's largest homebuilders.

stepping-stones, and other places that we previously had always walked on.

This way we were able to transform a mundane space, completely covered in asphalt—one we weren't particularly excited about—into a grand stage for adventures.

Next, I wanted to journey out into bigger more rugged terrains. To places I had never seen before. To places far away.

So what did we do?

It came to me that reducing our physical size was the key. If we could manipulate our size to become tiny beings, like in the film *Honey, I Shrunk the Kids!*, then this space that we always played in could turn into a universe of infinite dimensions.

Of course, we cannot physically shrink ourselves. And typically at this point adults will decide that this is a delusion and go back to their ordinary lives in defeat. But kids know better. Kids will start to seriously think of methods to shrink themselves.

I borrowed the imagery of a very "acrobatic" golf course directly from CoroCoro Comic's *Pro Golfer Ape* and decided to try it out by turning the entire company estate's grounds into a golf course. But just playing golf wasn't going to reduce my size, so I swapped the golf ball for a tiny glass marble.

And guess what we had! The scenery of the company home, from the glass ball's perspective, all of a sudden turned into a humongous mysterious golf course! The lawn behind the buildings turned into a fairway, the tall wild grass growing behind the community center became the rough, the puddle was a water hazard, and a small patch of decorative bushes transformed into neatly trimmed trees surrounding the course.

Without physically altering a thing, we brought a massive space to life, like creating an illusion simply by having a switch of thoughts. Little by little, I started to see the company homes, which I disliked, as something of interest.

But something was still missing. I wasn't completely satisfied. The pogo stick and the tiny glass marble golf were made possible through a conceptual shift, but physical excitement did not follow. To have a thrilling adventure, the experience of fear was a necessary element. Something was still missing.

One day as we were thinking about going to play by the ocean, we noticed a storm drain that ran from the company homes. It was big enough

for a person to easily enter. Along with concrete lids, it had some metal gratings. People probably entered through them for maintenance, we thought.

The metal grating really caught my attention, and we looked in through it. It seemed there wasn't much water at the bottom. It was probably ankle deep at most if someone my age were to step into it.

We stopped for a moment to wonder.

Where is this water going?

Maybe it flows into the ocean.

Taka and I looked at each other and ran back to our homes to grab a flashlight. With rain boots on our feet, we lifted the barred lid and in we went. The dark tunnel stretched on for a long distance.

Feeling an adrenalin rush, we decided to walk through the drain.

And so the adventure began. This time the element of fear was definitely present. Fear and curiosity. My heart was pounding loudly, alternating between these two opposing emotions. "This is what I call an adventure." I strongly believed so. The boring view of company homes morphed itself in an instant, and made me even more excited that we had discovered an adventure—one that reminded us of *The Goonies*—that had been hidden from us up until that point.

Frighteningly large insects that resembled massive mosquitos that we called *gagambo*, were flying around in the sewer. Since we couldn't see anything, it felt as if there were fierce creatures in the tunnel, holding their breath, waiting to snatch us.

Just as we thought that we couldn't go on, and were about to turn back, we saw a distant light at the end of the tunnel.

It led to the little dirty river that we always crossed over on our way to get to the ocean.

There we were, looking up from the river that we would normally look down on from atop the bridge. It was the exact same physical space, yet a change in perspective brought out a completely different world. The act of "changing" did not necessarily mean to change the company homes into a jungle through some major landscaping project.

To change the way you walk. To change your perspective. To change the way you think.

The world dramatically changed just by this. I learned that there are countless numbers of ways for me to "live."

We finally found ourselves at the end of the tunnel.

The ocean was so different from the ocean that we had known. It too, had changed its appearance according to the different path we took to get there.

From that point on, I learned to like the company home environment that I lived in.

I learned to discover adventures in any place and time, no matter how utterly boring my surroundings were.

A revolution isn't the act of physically "changing" something. But rather, to come upon a realization through a shift in one's own perception, that a revolution has already been happening. This is a type of methodology; not so much about "changing," but about "expanding." It is the skill of realizing that there are countless numbers of ways to "live."

It allows you to change the entire basis of your "living"—just like that.

This childhood adventure in the storm drain is the origin of my current thoughts and philosophies.

CHAPTER 1

Countless Layers Already Exist

1. The Layered Lives of Street Dwellers

This House is Only the Bedroom!
HOUSES made of blue plastic tarp lined the Sumida riverbank I was walking along. It was the year 2000. Twelve years ago. Despite being a fourth year student in the architecture department at Waseda University, I was out walking about with no intention of participating in job hunting activities nor wanting to establish my own design office; without any dreams or prospect for the future, only a vague desire for something to show up.

Like many others at the time, I perceived the owners of these improvised dwellings merely as "homeless" people. But something caught my interest. If what I was learning about in university was architecture, then these should be architecture as well. But these "architectural structures" looked so small and frail. They didn't suggest many possibilities. In fact, they made me want to offer my support in some way.

Then I came across this one particular house. At first glance, it was just another one of those blue tarp houses. But there was something interesting on the roof. Surprisingly, it was a small solar panel. I had never seen a high-tech house like this one among the others, so I knocked on the door. On entering, I found that the house was quite small, about the size of a single *tatami* mat[*]. And to my surprise, everything was electrically powered. When I measured the frontage, it was precisely 900 mm—carefully and delicately built.

This is it, I thought. Out of all the architecture that I had seen thus far, this one was closest to what I had envisioned. Perceiving the city as a natural environment and utilizing Tokyo's natural resources (trash), this house was built by hand according to the measurements of the occupant at a total cost of zero yen. The fact that the house was created to

[*] Tatami mat: Although various regional differences exist in the precise measurements of the size, one of the most widely used Kyōma type is 955mm x 1910mm. It is also worth noting that tatami mats are always made with the length exactly twice that of the width, an aspect ratio of 1:2.

match the occupant's physical body and lifestyle, fundamentally differentiated it from the usual modern-day houses attainable only by purchasing or renting.

And this was the home of one of the people that the world considered "homeless."

Listening to him talk, I understood without a doubt that this was a home. And at the same time, I realized that *I* was a homeless person living in a borrowed house and a borrowed life.

But his house was very small. So small, that it almost felt uninhabitable for a human being. An area only 40 cm larger than the length of a tatami mat. I said to him, "it must be difficult to live in such a tiny space."

He replied, "Nah, this house is only the bedroom."

I didn't understand what he meant. And then he started to explain:

"When it's sunny out, I can either read a book at Sumida Park next door, or I can play the guitar while looking at a junior high school music textbook that I found. The toilet and faucet are in the park and I can use them as much as I want. Once a week, I go to a nearby public bath. Meat and vegetables are given to me when I help out at a supermarket, cleaning up after-hours. So, I only need a bedroom-sized house."

Listening to him talk, I experienced a revelation. The seedling of the thought process that I would later spend so much time verbalizing, had its roots right here.

For him, the park is a combination of his living-room, toilet and sink. The library is his bookshelf, and the supermarket functions as a kind of refrigerator. And his house, a bedroom.

I called this "a city under one roof." The living quarters that allow him to conduct his daily life aren't just comprised of his house. But rather, the whole cityscape that he spends his time in, is one big home in his view. Just by shifting the angle of your perspective, the same thing can have a completely different meaning. His house, his way of living, the way he perceives the city—countless numbers of layers were present.

The layers that he sees differ from the layers that regular people in society see, therefore nobody notices and nobody interferes. At the same time, he has no problem if other people also use his layer of space. He is practicing a way of utilizing space which is a complete departure from the present concept of ownership. This departure is also different from the idea of communal "co-ownership" that is often spoken of today. Furthermore, he has succeeded in taking his philosophy of perceiving space and applying it to his daily life. He is truly living—to use my own words—a "layered life."

COUNTLESS LAYERS ALREADY EXIST

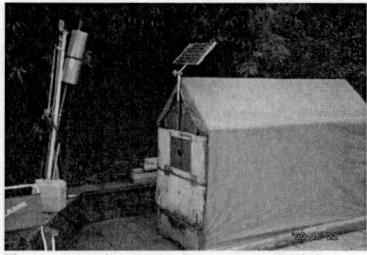

The blue tarp house I came across in 2000 by the Sumida River. There is a solar panel on the roof.

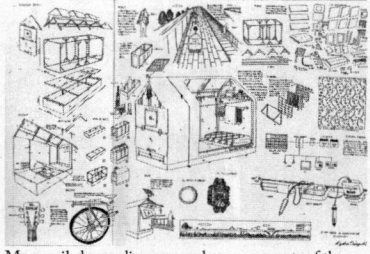

My pencil-drawn diagrams and measurements of the house.

This could also be considered a bricolage form of ownership, one where we manage just with what we have, like that suggested by anthropologist Claude Lévi-Strauss. My instincts told me that this may be a useful reference point in thinking about a new way in which houses could exist.

Mr. Suzuki's Asakusa and My Asakusa

After this initial encounter I continued to explore the homes of the so-called "homeless." Their houses weren't commercialized products, but were rather more akin to a primordial nest for a human being, built on a zero yen construction budget of course. The more I observed their lives, the more inspiration and sense of direction I found.

They were building houses using the surplus that the city throws out—usually regarded simply as trash. We tend to think of building materials only as commercial products. But they have found, where we have failed to recognize, a form of "natural resource" that is constantly available for harvest. And that is the city's solid waste.

I decided to call the surplus material that the street dwellers were making use of the "fruits of the city" (I have written on this topic in detail in a book called *Starting an Urban Hunting and Gathering Lifestyle from Zero*. The same physical material, due to a simple shift in perspective, is transformed into a completely different type of resource. Again, we are able to perceive a layered structure here.

What I might consider merely trash, for street dwellers, could be valuable building material for their houses, or resource that could be exchanged for cash. Observing the lifestyles of street dwellers in this way, I gradually began to see that their layered structures existed not only in their perception of homes but also in their general approach to life.

For example, walking through Asakusa[*] with Mr. Suzuki, a Sumida River

[*] Asakusa is a district of Taitō ward, Tokyo, located by the Sumida riverbanks. It is known for its more traditional appearance and atmosphere, as well as its trademark temple, Sensō-ji.

resident, the place starts to look completely different from the Asakusa I knew. "You can find batteries thrown out at this electronics store every week. This sushi restaurant disposes of perfectly-good sushi rice every day. In the brush next to this parking lot, you can harvest *tara*[*] shoots. The new spring leaves of this persimmon make delicious tempura…"

In other words, Mr. Suzuki had a completely unique map of the town. Just as a geologist would draw contour lines or trace over existing maps, his Asakusa was completely different from mine.

Mr. Sasaki's Philosophy

Mr. Sasaki, another street dweller, also had his very own map of Asakusa. He is a treasure hunter who finds gold and rare metal in trash bags. Every month his finds amount to a remarkable 500,000 yen in value. Women who purchase pieces of rare metal jewelry on the layer of trends and fashion, throw them away just as easily, not knowing the value of such minerals. And Mr. Sasaki gathers them up as if he were a Western prospector during the gold rush.

Mr. Sasaki lives by one simple rule; he "hates having to pay money." So he looks for ways to eliminate meaningless spending as much as possible, and in turn thinks of ways to convert everybody's trash into monetary wealth.

He once borrowed a place to live. Or in other words, someone offered him shelter. The owner told him he didn't have to pay rent if he took care of the utilities. But since Mr. Sasaki hates spending money, he decided to get his electricity from a car battery that he brought into the house.

Mr. Sasaki is a pro when it comes to using batteries. He always used to have a car battery mounted on his pull cart so he could test household electronics thrown out on roadsides. He made a living by selling the usable electronics to secondhand shops. So he knows how to make anything work, from refrigerators to washing machines, by using only a car battery.

In addition to eliminating the cost of electricity, he fetched water from the park. So although he was living in a room inside a regular house, he was living on zero yen. Even so, some things are always bound to be a hassle. Well, apparently those things just added to his amusement.

"Having fun doesn't cost you money"

That was Mr. Sasaki's philosophy.

This too, I believe, is a very pragmatic way of thinking when we consider future ways of living. A house can be just a box. You are able to detach

[*] Japanese angelica tree. The sprout of the tree is often fried in batter, eaten as tempura.

the utilities from the housing structure when you deal with each one separately. Just by doing this, you no longer need to spend money, put stress on the environment, nor live with dependency on electricity companies. And, it's fun! To overcome things that appear to be a drag, just make it profitable and enjoyable.

Through his wisdom, Mr. Sasaki has become a renown rare metal miner in and around Asakusa, and now resides in a hotel room. He even periodically visits the red light district. In his own way he is living a very satisfied life. People with thinking processes like these can unintentionally become "rich" in this societal system. Being forced to really "think" due to a lack of money, ironically proves to be actually quite profitable.

As far as Mr. Sasaki is concerned, making 500,000 yen per month with no initial investment, he is free from any of the worries that infest modern day society.

"Even if you end up homeless, you can change your way of living by simply knowing what's fun. I can't understand what everyone else is doing," he says.

Thinking Simply

Have we lost our minds, unable to even imagine the possibility of a lifestyle like Mr. Sasaki's? Why do we think that we need money—for water, for heat, for food—to live? Haven't we become fools by not exercising our ability to think? And to make things worse, fear and anxiety are fueling misperception.

If we were to properly collaborate as a community, wouldn't manifesting a "zero yen lifestyle" be a simple enough objective to accomplish? I wondered about this question while observing the lives of the zero yen homeowners. Could it be that difficult?

Furthermore, even if a lifestyle that didn't require monetary spending were possible, work should be something you'd want to continue for a long period of time. Someone who endures a job they dislike, simply for the reason that it costs that much to live, according to Mr. Sasaki, is "a fool." In other words, they are not "thinking" at all.

When I make statements like these, people often tell me: "Well, you never worked at a company, so you don't understand." or "You know nothing about the harsh consequences of ditching work." Or they would say, "Then how would society be able to grow?" Or, "What's going to happen to the economy?" Or, "The reason people can survive on the streets is because the rest of the population works and lives regular lives." And on and

on…

By then you realize that society has become a place where you can't even go on strike, a system reminding you of slavery. Yet nobody considers it strange. People cannot even begin to imagine that there are also alternative layers of living. This is the reality.

But I feel that this reveals the same problematic structure as how a bank would go out of business if everybody completely paid back their loans. I call this the "thought process of debt." The idea that "borrowing money gives you great motivation to start working!" is an example of this kind of thinking.

Something about taking out a 35-year loan, carrying a massive debt, and then having to work your butt off, therefore allowing the companies and the banks to continue functioning, and then saying "Hooray for economic growth!" just seems utterly strange to me. People like to tell me that it isn't that simple. Yet when I ask them, "Well okay then, what sort of complex system is it?" nobody can answer. They don't understand it themselves.

Things that aren't understood need to be pondered on and answered. It's that simple.

We should build a habit of thinking about things on simpler levels. If we don't, we won't be able to deal with the complications of society.

Thought Gives Birth to Space

Let's worry about the economy later and return to discussing the many "layers."

Everybody perceives the town of Asakusa in their own different way. This may seem an obvious statement, however it's not something people recognize on a daily basis. This was revealed to me through my research on street dwellers who lived in very different spaces from my own. And I decided to call each person's space a "layer."

Human beings have always tried to expand their territories within this single space we call earth. All wars and disputes, quarrels and grudges, ultimately are rooted in this single fact. Here in Japan, obtaining more money, land and possessions has been a fundamental motivation for all economic activities and everyday living. Street dwellers though, exist as an exception.

The world of architecture that I belonged to was based on the motives mentioned above as well. Architecture presumes that building structures on acquired land creates space. But is this even true? No, I don't think so.

That's because however many walls you build on the land you possess, there is no increase in space. In fact, there's even a decrease.

Street dwellers perceive "space" in a different way. Not being able to afford to purchase land, they've had no choice but to give up the idea of private ownership altogether. This is how and where they began creating their own layer—a completely different layer from that of the impersonal "*anonymous*" societal system that everybody in Japan thinks of as the standard.

Street dwellers aren't magicians. They simply exercise their abilities as thinkers. Where architecture fails to create space, thought succeeds.

Mr. Suzuki's front door taught me that the consciousness of a "layered life" can manifest its creativity into physical space. By closing the door along with the blue tarp covering, and filling a plastic storage container with hot water, this entrance becomes a bath. In addition, a knife cabinet appears when you open the door, and the space instantly morphs into a kitchen. Depending on where you stand in relation to the front door, the function of this single space transforms as well.

Basically, by using layers, the amount of space increases accordingly. It's the exact opposite of the "how can we divide this space up with walls" way of thinking that architecture has used up until now. Walls are unnecessary. Humans already have the innate ability to create space after space, without visible demarcation.

This "layering" I speak of here is not a new technique. It is rather a power that has existed within us since ancient times.

Dai-chan's Discovery at the Tama River

I would like to introduce you to another intriguing street dweller, Dai-chan, one of my best friends. He doesn't like it when I call him homeless, since he isn't illegally occupying any public space, and is rightfully residing in his own home.

His house is located between the riverbank and the street that runs alongside Tama River[*]. This piece of land had been on his mind for some time because of the thick grass that invaded the patch. He's a neat, tidy type of guy and this unkempt grass unnerved him. He thought, "This land probably belongs to the ward or the country, someone should come and clear this grass," but no one did anything.

Feeling increasingly concerned, Dai-chan decided to give the grassy patch a trim himself. What a straightforward act of social service; he

[*] Another major river that runs to the south of Sumida River, into Tokyo Bay.

simply wished to make the city look neater and cleaner. Dai-chan, a street dweller living under a bridge, had already been living on an alternative layer at this point. This piece of land became neat and clean, thanks to him of course. From then on, Dai-chan kept an eye on the land, and its neatly-cut grass.

Though surely it belonged to someone else, Dai-chan, having cut the grass, began to perceive the land more like a friend. His way of looking at the land had changed. He started to wonder if it was an abandoned piece of land—as if it were an orphan, or an unwanted kitten left out in a cardboard box.

Eventually, he began to wonder if the land actually even belonged to anyone at all. And his wonder wasn't the kind aroused upon finding a loophole of some sort. It was indeed as if he had discovered a lost kitten in need of some care. He went to the legal affairs department, examined the official map of the district, and searched for the owner of the land. He asked around as well, of course. Ultimately, he came to the rather surprising conclusion that the land actually had no owner at all.

Later, after further investigation, Dai-chan found out that this land had long ago been disputed over by the national government, Ōta ward, and a Shintō shrine that stands right in front of it. However, when it proved impossible to reach a decision as to whose property it should be, it was eventually given up on and abandoned. To his astonishment, he had discovered a piece of Japanese soil that belonged to absolutely no one.

Since it wasn't in his nature to turn a blind eye on a poor abandoned kitten, Dai-chan decided to live on this piece of land. He has been living here for eight years now. Dai-chan is now the proud parent of this land. And since he looks after it as if it were his own child, no one says a thing.

After witnessing Dai-chan's relationship with his land, and realizing that ownerless land exists here in Japan, I started walking the city looking for my very own kitten to adopt.

If I'm looking for land, I might as well look where the most expensive ones are, right? So I headed straight to the yon-chōme and Miharabashi intersection of Ginza[*], where there was a curious patch of land that I had been wondering about for some time.

On each of the four corners of the intersection are triangular pieces of land that look like government-owned property. Yet there were shop signs and advertisements on them as well, so they seemed to be used for

[*] Located in the Chuō ward of Tokyo, Ginza is known as an upscale shopping district and has some of the highest land prices in the world.

business purposes. That in itself was rather unnatural, but there was something else very strange about the site.

One triangle out of the four had absolutely nothing on it at all, while the other ones were annoyingly cluttered. So I decided to conduct some research. As a result, I was able to find that the land's ownership was in dispute between the national government and the city of Tokyo, and it had been left alone and forgotten. Needless to say, this information wasn't provided by the Tokyo Bureau of Construction. The owner of a bar called *Mihara* in Miharabashi's underground shopping arcade informed me of this, having researched the mystery himself.

This is how I obtained my own piece of land just as Dai-chan had done—in none other than Ginza, yon-chōme.

The Law Rubs the Multiple Layers Together

A societal system where things look stable—a city's infrastructure for example—exists on a layer where everyone can live and adjust without thought. You could call this an "anonymous layer." Since there is no "thinking," there are no "doubts." This societal system could be considered reality. It is, however, merely one reality amongst many possible realities. I choose to have doubts towards the idea of a singular reality.

The first question that the conscious street dwellers I met asked was, "Are humans really incapable of living without money?" What can be used as a clue in solving this question? What exists in common among the multiple layers? Well, one such thing, surprisingly, is the law.

At a glance, the law may seem to be at the pinnacle of a rigid societal system. However, the layer of the anonymous societal system and the law do not equate each other. Why? The layer of the societal system, the anonymous layer in which we selfishly and incorrectly believe we reside, in actuality, has no substance. It is in no way any different than the layer of the street dwellers. It simply means that you have that point of view. You may even call it an illusion.

The law is different, however. The law is written out for everyone to see and examine. Land and architecture are similar physical realities as well. It exists in a place different from our non-physical societal system layer. Moreover, these physical matters never enter layer forms. This is proven by the fact that there is only one Asakusa in this world. But when human consciousness enters the equation, we witness the birth of my Asakusa, Mr. Suzuki's Asakusa and Mr. Sasaki's Asakusa.

In other words, although the law itself does not physically change, it

does—tremendously—according to the human consciousness perceiving it. That is why verdicts can vary. Law is where the many multitude of layers are rubbed together. Public administrations also are similar entities by nature.

With that in mind, I decided to check out the law. My question is, "Am I allowed to live?" I'm talking about the right to survival. Let's find out what goes on here…

The 25th Article of the Japanese Constitution: *All people shall have the right to maintain the minimum standards of wholesome and cultured living.*

Apparently the right to survive is guaranteed to us even if we don't have money.

But you cannot rent a house without money. And we may think that if we aren't able to rent a house, then we won't have a place to live. Is this really true? As long as land is available, we should be able to live on it. What if we don't privately own any land? Where else then? Simple. On national land. Since it is public land reserved for citizens, this must be allowed.

And for this reason, many people took to the riverside land owned by the government. All land along the riverbanks—except for privately owned property—belong to the government. For this reason, people built little huts to live in along the river.

However, the riverbanks have a law known as the River Law:

The 26th article of the River Law: *Any person who intends to construct, reconstruct or remove a structure on the land within a river zone shall obtain the permission of the river administrator.*

Not getting permission can lead to penalties. Yet a form of hierarchy exists even among laws, and the constitutional right to survival—being the dominant law—makes it highly unlikely for the River Law to be imposed. For this reason, the zero yen residents in houses along the riverbanks still reside there today without being evicted.

Biwa Planted on National Land Without Permission… Whose Fruit is It?

The interesting thing about this is that the national government also realizes the hierarchies in law. That's why they cannot forcefully evict people based on the River Law, for that would threaten the constitutional right

to survival.

Here is a specific example. Mr. Funakoshi, a.k.a. Robinson Crusoe of Tama River, has planted a biwa tree in front of his house on a riverbank near the Rokugō area. An interesting signpost standing next to it reads:

"This biwa tree is privately owned property. Please do not steal the fruit. Whoever steals will be prosecuted on the basis of theft."

A fairly normal sight if a biwa tree was growing in somebody's backyard, probably, but this one is growing on national land along the Tama River. Furthermore, it was a "street dweller," Mr. Funakoshi, who invited himself to live on the riverbank and plant this biwa tree without permission. Did you not feel a sense of arrogance here? "What is he saying? He can't just change national land into private property!"

I asked him.

"Mr. Funakoshi, aren't you living here illegally?"

"Of course. It's against the River Law. There are penalties for it."

"I must say, that taking biwa fruit from a tree planted by an illegal resident doesn't appear to be so illegal."

"Nonsense! Those are two different matters. Whether it's on national riverbanks or not, if somebody claims that something is theirs, then it's theirs. Even if it breaks the River Law, I planted the tree there, so I can claim ownership. If someone takes the fruit, then of course I can sue them for theft, because I planted it, regardless of the fact that it's on national land."

I called up a free-of-charge law consulting firm run by the local government and asked a lawyer. The reply was that Mr. Funakoshi's ideas were most reasonable.

"Basically, I am claiming my right to survival." Mr. Funakoshi adds. "So I don't think there's anything that even the River Law can do. That's why I've been able to live here for 20 years. Who do you think land belongs to? Nobody. So people should just go on living, sharing with each other the best they can. And really, the people in charge know this too. That's why I haven't been kicked out."

The law is quite a fascinating thing. And Mr. Funakoshi has a good grasp of it. The way he utilizes his perspective could even be called a survival technique. Countless layers in fact exist within the concept of ownership as well.

Just as this example shows, the concept of layers can be similar to Russian nesting dolls, with layers existing within layers, and when used skillfully, allows you to be free from the burdens of the anonymous system.

The law, and physical things like land and the city, are what you find at the fulcrum of these many layers. It's a matter of what layer we choose to perceive them through. After observing how street dwellers lived, I felt the great potential in living amongst alternative layers.

That is why I say this: There is no use trying to change the societal system, law, land ownership, architecture, or urban design. The very act of physically trying to change something means that you have already been assimilated into the anonymous layer. Instead, perceive and broaden the multiple layers included inside of the things that already exist. This isn't about "changing," but about "expanding." That is the layer revolution.

2. Putting Wheels on Homes—Mobile House

We Aren't Thinking at All

PRIOR TO the Great East Japan Earthquake that hit on March 11th 2011, street dwellers were already facing a tough social environment, much earlier than the rest of us. They had lost their jobs, their money, their place to live, and on top of that, nobody was offering them any help. They inevitably had to resort to learning how to survive. In this context, they are our seniors as well as our teachers.

With evident homelessness on the streets, combined with the number of suicides, Japan had been filled with despair long before the earthquake hit. Yet it seems as though we are incapable of recognizing this despair until it has reached our own physical proximity. When I proposed that these street dwellers are living textbooks on how to survive the coming era, hardly anybody paid any attention. This is just how people are. I've heard it said that those who *aren't* in desperate situations give the support and provide aid for others in need. Well, I had a different take on this. It didn't work that way in this situation because we were already living in a desperate society under a desperate government—all of us.

We all complain about dysfunctional politics and social conditions, yet a lot of us fail to consider this a life-or-death situation, and therefore end up not trying to actively bring about any change. For the street dwellers, however, their lack of cash and a place to live concerns them directly as a matter of survival. In this situation, can anything really be accomplished by complaining to politicians or administrators? Would any government organization offer a helping hand?

Sadly, no. Politics and administrations are not systems that strive to

save your life. I mean, we already know this very well. We cannot expect an anonymous system to embody human emotions. Dealing with matters of life or death requires the presence of "emotion."

Observing the many who complain yet stay idle, in comparison to those acting to survive on the street, I realized that we aren't "thinking" at all. Because, as I've mentioned, there is no need for us to think as long as we remain within the anonymous system.

What does it mean to "think"?

I define "thinking" as the act of developing a strategy on "how to survive." It is to internally consider "what it means to live," while analyzing and making sense of the external environment. This "thinking" is eliminated in an anonymous system. The system makes us believe we'll be just fine without having to think—when in actuality we are made to not "think."

The street dwellers simply began "thinking" about the very basics of living; probably what, for some people, philosophy is meant to be. Not belonging to the stable anonymous system however, they were required to philosophize on "life", not only figuratively, but concretely, from a survival standpoint as well.

Mr. Suzuki's Philosophy

Let's take another look at Mr. Suzuki, who has a rich twelve-year history of living on the Sumida riverbank.

For him, "living" is defined as "having enough to eat, having enjoyable friends to spend time with, drinking sake every day, and singing whenever you want." With this mindset he began constructing his "living" from scratch. We may be unable to construct an entire societal system from scratch, yet when it comes to our own "living", it's still possible.

First, he decided to look for a place to live. Human beings need a "place" to live; not necessarily a house, but a "place." It doesn't have to be a house as long as that "place" has a roof. He decided to go to Kototoi Bridge in Asakusa. If you're under a bridge, you've got a roof over your head. If it's cold, then just put up some cardboard walls and you have a place to dwell.

But the land under this bridge technically was part of Sumida Park grounds. These grounds in turn belong to the Taitō ward, and each ward has their own designated police officers. One such officer from the Taitō ward told Mr. Suzuki that if he chose to remain on the grounds then the officer would have to enforce regulations and thereby remove him. Since the officer didn't want to forcefully remove him, he requested that Mr. Suzuki leave. Suddenly Mr. Suzuki was left without a "place" to live.

As mentioned, a "place" is needed in order for us to "live." But it seems these "places" are divided and separately managed by the law. For example, the grounds designated as parks belong to the various wards, and are policed by them. The same officer offhandedly told Mr. Suzuki, "Go to the riverbank. It's not in the ward's jurisdiction so the police won't bother you."

Although they appeared to be part of the same grounds, the actual park and the riverbank of the Sumida Park had been separated by an invisible line, and each had a different owner. The riverbank, as we came to know, was under the administration of the city of Tokyo itself, and ward officers were not authorized to regulate the area. Having realized how the grounds were divided up, Mr. Suzuki left without protest and moved over to the walkway along the river. There he built his house in an empty corner, and began to live.

Understanding how the Sumida Park and Sumida River exist under different ownerships, and how different wards and their appointed officers regulate their jurisdictions, Mr. Suzuki acquired his "place" to reside. This act is what I call "philosophy." He was able to transform an anonymous piece of "land" into something he could identify by name. He hopped from one layer to another, successfully finding a way to survive.

Here, his "thinking" involved the act of identifying the splits within the societal system layer, and discovering that many other layers also exist. Mr. Suzuki jumped from an anonymous layer onto his own newly-formed original one.

This, is "living."

It is to physically interact with your surrounding space while perceiving its many details, and surviving through doing so. These skills demonstrated by street dwellers, will become a necessity in the times to come.

Encountering "Emotion"

After Mr. Suzuki confirmed that the "place" he had found in this new original layer was safe, he proceeded with plans to build his new "house." A house, in an anonymous system, has always been considered something that is acquired by exchange of money, however, Mr. Suzuki did not have the cash to purchase a house nor the materials needed to build one. He walked around town thinking of ways to acquire his needed materials.

At this time, Mr. Suzuki had an expanded sense of perception of the town due to his lack of money. While we tend to always overlook the layer of surplus which we call trash, for Mr. Suzuki this layer was the hunting ground for finding material. Upon realizing he could build a house

entirely out of trash, he went to work. In this day and age, the only free materials are those in surplus.

On occasions such as the fireworks festivals at Sumida River, all types of materials are thrown away, even large sheets of blue tarp. They are all of course things that citizens took upon themselves to litter. Mr. Suzuki collected the discarded materials with mixed "emotions." There was loathing towards the people for continually wasting, while at the same time he felt elated at being able to pick up new materials.

On the anonymous layer things exist as "products," and are obtained only through the exchange of paper currency of equal value. There is no emotion here and everyone subconsciously has a sort of anonymous acceptance that this is the way things are. There is no place for human emotion to enter in these exchanges. However, when you shift away from this economic exchange and realize that the world is multi-layered, it is then that "emotion" comes into play.

The area of human intuition also becomes very effective when living amongst multiple layers. Human emotions and intuitions, despite not being conveyed by words, vividly come to life. The act of thinking about what it means to live eventually leads this primal thinking process into becoming a physical process—a natural human lifestyle that is possible even in a concrete jungle.

Mr. Suzuki's "house" came together in this way, by finding a "place" to live in an original layer, and by using leftover "material" from the surplus layer. His structure built from gathered materials is no different than an animal's nest, and is the result of being able to perceive the city as a "natural" environment. The building expenses amount to zero yen. The land expenses are also zero yen. This structure can be considered a natural piece of vernacular architecture local to Asakusa, Tokyo.

What Mr. Suzuki gathered weren't simply products, but natural material invested with "emotions" related to his attitude. Mr. Suzuki used the trash he collected to make not only his house, but the houses of many others as well. There was no concept of loss or gain, only the hope that the "trash" could be further utilized to expand living spaces for others. That's true human kinship.

Before he knew it, a large community took shape. All kinds of trash were collected and became plentiful. Almost anything that was wanted was available despite, of course, not spending a single yen. They eventually even managed to set up a karaoke machine. Office workers and Chinese exchange students became part-time members of the community as well.

It became a community, rich with non-monetary donations, creativity and talent.

There's No Use in Complaining

The community's electrical system was also thought out and constructed from zero. How do you obtain electricity when you don't have access to a regular 100-volt outlet? Mr. Suzuki gathered discarded car batteries from a local gas station, read books on electricity from the library and thought up a practical 12-volt method for everyday use. This way he could use electricity without relying on infrastructure. He thus constructed his own infrastructure layer.

After witnessing his actions, I felt that there really was no use in complaining about politics or administrations. It was easy to see how little the politicians and administrators cared about the lives of people, especially after seeing the way they dealt with street dwellers. I mean, the constitutional "Right to Survive" is ignored to begin with. There's just no use complaining about a machine that's bound to break down.

Mr. Suzuki's survival method also gave me the awareness that though it might not be possible to create a system from zero, creating *political action* from zero still is. His action of obtaining his own house is indeed a political action. And it is a philosophy at the same time. This, to me, is "living."

The political system broke down into its current disorderly state because we refused to think. Even though we realize this, we still are unable to stop it from neglecting life, because we continue to not "think." So why don't we learn from the street dwellers and activate our own "thinking process?"

That's when I arrived at the concept of the Mobile House, which I will describe to you next. It is the embodiment of what I learned from the street dwellers.

A Movable house Called a Mobile House

I wanted to find a way for a house—a "living space"—to exist differently from those constructed in today's normal residential environments; different from those that come connected to an infrastructure, which are practically rent-collecting devices. This was my attempt at expanding society; applying my research on the habitats of street dwellers and taking it a step further.

"Why do we have to pay rent in order to live?"

This was my very basic question. Yet when I threw this question at other

people, most found nothing odd about it at all. To them, it was nothing more than common sense; rent is what you pay, and a house is what you buy. Still, our neighbors by the riverbank have managed to build houses for zero yen, and have also managed to pay nothing for the land. This is a fact, yet we still have no doubts regarding the payment of rent. This appeared to be a mystery to me.

I don't object to the idea of paying rent itself. However, I do feel that this modern form of residential systeming—being the only one we are allowed to live in—is threatening our right to survival. In other words, it is unconstitutional. A nation should ensure that the opportunity exists for all persons to have the right to a residence.

But hey, there's no use in complaining. There's only one valid solution, we have to take action in order to live.

I tried to move the concept of "house" away from the automatic rent-collecting form that we've been familiarized with, and more towards the house that Mr. Suzuki had created. While it is true that Mr. Suzuki's house isn't considered a house by law due to the fact that it isn't permanently attached to the ground, it still is a "house" emotionally nonetheless. I tried building a house from that point of view.

Mr. Suzuki's house, is a house that isn't considered a house. What we have is a house that isn't attached to the ground; a house that can move.

If you read the Building Standards Act you will find that a movable house unattached to the ground isn't considered a house. You can build one without a permit and property tax does not apply. It's a house liberated from the law.

With this discovery in mind I put four wagon wheels on the house. As a result, my Mobile House was now considered a "vehicle." Furthermore, as the house was constructed for less than 30,000 yen, there was no fixed asset tax. The Mobile House is about three tatami mats in size, and the addition of solar panels provides self-generated electricity capable of powering electronics such as iPads and iPhones.

The next problem was where to "place" the Mobile House. All grounds, in actuality, are categorized differently. I learned this from Mr. Suzuki. If built on residential land, the house then becomes a residence, and therefore becomes expensive and far less flexible. So I began to reinterpret and expand on what kind of places structures can exist on.

A Mobile House is considered a "vehicle" by law. A "vehicle" can be placed freely, on farms, parking lots, etc.. And there are indeed many parking lots in Tokyo. But would I find owners willing to let me keep such a

My first Mobile House parked in a lot in Kichijōji, Tokyo. I even had pizza delivered to my door.

thing in their lot? The third landlord I asked gave me the go-ahead. The decision whether to allow a house-like "car" to be parked on the lot rests with the owners. With their understanding, everything is fine. But I was asked one question:

"You aren't going to be living in this thing, are you?"

"Nah," I replied immediately.

If I had answered differently, I wouldn't have been allowed to borrow the space. But I don't like to lie; in actuality I would indeed be residing there. But then again, what does it mean to "reside"?

For the answer, I decided to check out the law once again. What I found was surprising.

In Japan, there's actually not one single law that defines what it means to "reside."

Does it mean you are residing when you have serviced water? Or when you're lying down for a rest? Or maybe even when you're eating a meal?

"Residing" cannot be specified. In the law, there is mention of "houses" that generate tax, but a "residence" does not exist. Consequently, you can reside in any way you want.

We have "Freedom of Residence" here in Japan! We can reside in any way or form we want. This might just be a spectacular country after all.

Cheap, Simple, Re-buildable

The first Mobile House I built cost precisely 26,000 yen. You can design one however you like, as long as it's on wheels. It's such a small piece of architecture that any novice would be able to design it.

In the current society, putting a sudden halt to the monetary economy would be impossible. Even the street dwellers have yet to free themselves from it. Although there are few extreme examples of people committed enough to have fearlessly given up on paper currency, on a grand scale this is still unrealistic. But if we are going to decrease our dependency, the Mobile House is a practical tool for that.

There should be no need for people to exert themselves with strenuous company labor if a house costs only 26,000 yen, don't you think? Furthermore, personal farm plots (15 m^2 per unit in Kumamoto) can be rented for 5,000 yen a year. If we were to place a Mobile House on one of

them, then the rent would be a mere 400 yen a month! This means the purpose of labor will naturally change as a result. On top of all this, the house is moveable. For example, after the 3/11 disasters, I relocated a Mobile House from Kichijōji, Tokyo to Kumamoto on a two-ton truck for 50,000 yen.

In February of 2012, I made three Mobile Houses simultaneously for a gallery at the Kanagawa Arts Theater. It took me a total of three hours to design all three houses. It's just that simple.

Mobile Glass House

This time, unlike my original Mobile House, these Mobile Houses had a bit more substance to their design. The first, *Mobile Glass House*, had features resembling the architecture of Phillip Johnson. The second was the *4D Garden House* based on a miniature garden cultivated by a hobbyist I interviewed in Tokyo. And the third house was the two-story *Window House*. These festive-looking houses can be built with great ease. You don't even need a ruler for the plans, they can be done free-hand on a whim.

4D Garden House

I am no specialist; not even close. I'm just a guy frivolously calling myself an architect, without even holding a license. It just goes to show that a license isn't needed to build a Mobile House—anyone can do it, and cheaply at that. While these three houses are somewhat elaborately detailed, the total cost was still only about 70,000 to 80,000 yen each.

Window House

After seeing this, it becomes rather obvious how foolish it can be to spend tens of millions of yen on a house. A good decent-sized house can be obtained by spending roughly 300,000 yen and will be spacious and sturdy enough for comfortable living.

A house should naturally be three things: cheap, simple, and re-buildable; a kind of vital sidekick for living.

3. March 11th, 2011

When You've Hit the Bottom

THROUGH BUILDING Mobile Houses, I concluded that building a lifestyle from zero isn't difficult at all. What I also realized was that people have many ideas, yet most of these ideas are never attempted.

The idea of building Mobile Houses has in fact been around since the 1960's. To go back even further, Kamo no Chōmei[*] made a mobile "hōjō-an" during the Kamakura era [1185-1333]. He was gazing with disbelief at people who paid large sums of money to acquire housing and were thus tormented by a life of labor. "A house isn't something to be bought." He knew through his own experience that building your own house made for a more efficient and resilient home.

Too often, people do not attempt. They are too quick to assume things.

However, by simply attempting, a house—assumed only to be obtainable by paying tens of millions of yen—is obtainable for a mere 30,000, albeit in a smaller size. I had initially assumed that they would have to be parked on purchased land here in Japan. However, there are many vacant spaces in Tokyo, and most of them have been turned into parking lots and luckily many of the lot owners want their spaces to be put to use, plus, even if the Mobile House looks like it was built for people to "reside" in, simply explaining it as a homemade camping vehicle will allow you to rent the space on the lot.

So why don't people "attempt?"

I was left to wonder. And at the same time I also realized through my own attempts why the street dwellers were so confident in knowing they would never starve to death.

The more attempts you make, the more wisdom you absorb. Your fears diminish, enabling you to endure and live through the difficulties you're faced with.

This is because by attempting, you have enabled yourself to know.

[*] Kamo no Chōmei (1155-1216) was a Japanese author, poet, and essayist. After losing his political backing as son of a Shinto priest at Shimogamo shrine in Kyoto, he became a hermit, living outside the capital. In his celebrated essay *"Hōjōki,"* he describes his hand made ten-foot-square hut as "a hut where perhaps, a traveler might spend a single night; it is like a cocoon spun by an aged silkworm." (translation by Donald Keene)

To know the "amount" of what is required for your lifestyle. To know the real causes behind your fears, and overcoming instead of worrying. To know what it means for you to live.

If you think from zero by yourself, you can accomplish anything. On top of that, in actuality, even the societal system is designed to allow for this. It's just that the people living in it misunderstand it. They believe they aren't capable of doing anything; that they will die if they have no money.

But the street dwellers have proven that wrong. They have acquired land, homes, and even vegetable patches through a completely different route than money. A lifestyle without insurance. A lifestyle without savings. But one also without worry. An ecosystem of co-operation.

We should apply more of what we can learn from them throughout society, and give everything a try. When someone complains, you will know where the line is drawn—between what the actual problem is and what society will allow. I realized that even without money, you can live a fun life just fine! Anything is possible! The Mobile House easily showed me this.

There are so many more interesting things to discover if you manage to peel off a single thin layer from everyday life. Mr. Suzuki has taught me that even if you are in despair, you are still able to discover this. Even if you cry, even if you feel frustrated, even if you lose all hope, there still exists a world for you to laugh in. Takeshi Yōrō[*] taught me this foreign proverb:

"When you have hit the bottom... dig at it!"

The Great Earthquake of Eastern Japan

While making these Mobile Houses, I thought it would be neat to start with these small ones and eventually have all houses powered by solar panels. Right around that time a friend of mine was going to take part in a protest against Chugoku Electric's forced construction of a nuclear power plant in Kaminoseki, Yamaguchi Prefecture. I thought about witnessing the scene for myself, so I went along with him.

That was towards the end of February 2011.

At the protest, there were many elderly women from Iwai-shima, an island located across the water from the proposed construction site. Their desperate cries sent tears trickling down the face of one security guard, tasked with silencing them. He had been sent there from Hiroshima Prefecture, knowing very little about the situation.

[*] Takeshi Yōrō (1937-) is an anatomist and professor emeritus at the University of Tokyo. He is also well known for his books on themes of society and people, written from his unique anatomical and biological perspectives.

Something isn't right. Even before getting into the pros and cons of nuclear power plant construction, there's something utterly wrong here concerning "labor" itself. I returned to Tokyo with a renewed sense of urgency, and went straight to work broadcasting for an online channel about nuclear power plants. That was March 3rd.

On this channel, I invited and interviewed Mr. Tetsunari Iida from the Institute for Sustainable Energy Policies, the documentary film director Ms. Hitomi Kamanaka, and even a friend who was working for Tokyo Electric. When I asked which nuclear power plants are particularly dangerous, Mr. Iida gave this warning:

"The power plant in Futaba, Fukushima Prefecture is in serious danger. An earthquake would be disastrous, a tsunami even more so. A large earthquake will literally destroy it."

Over a few drinks after the broadcast, I was informed by Ms. Kamanaka about the fears of radioactive iodine and the internal exposure of cesium. I even watched her film, *Hibakusha at the End of the World*, arriving at the conclusion that nuclear power plants were a huge problem.

Then, on March 11th, 2011, the Great Earthquake of Eastern Japan struck. On the following day, a hydrogen explosion occurred in reactor Unit 1 of the Fukushima Dai'ichi nuclear power plant located in Futaba, blasting an enormous amount of radioactive material into the air.

I must be dreaming, I thought.

CHAPTER 2

Between Private and Public

1. Who Does Land Belong to?

There is Something Clearly Wrong

FIRST OF ALL, we've all lost our minds. How about I begin there? I, being insane as well, discovered another world, free from this insanity: the non-possessive world of the street dwellers—and upon seeing their world, I recognized that I had been insane. However, they are the ones seen as outlaws in our world. This perspective enabled me to make many discoveries. It made me wonder about what the word "illegal" really means.

I felt I wanted to do some normal thinking. Why would you lose a place to live if you ran out of money? Isn't this insane? Animals live just fine without money. And at a fundamental level, the same should apply to humans as well. Yet people say the world would be chaotic if we were to become like the animals. Is that even true?

If that's the case, then why doesn't the animal kingdom exist in utter chaos? Why do they not slaughter each other? I don't understand the difference.

I mean, do people even really want to possess land? It just seems to me that people end up buying just to avoid paying monthly rent. Even having to pay rent does not seem quite lawful to me in the first place. Fundamentally speaking, land isn't originally meant to belong to anyone. ...I wonder about this like a child would.

Of course, paying money to use land is understandable. But the money shouldn't be going to any single person, and perhaps should instead be properly contributed to public funds. Upon simple ordinary thinking, it would be crazy for someone to walk away with this money. But this world isn't ordinary. It is insane.

What is this *rent* that we're paying? Why must an office worker in Tokyo slave away every day, at a job s/he doesn't even like, to earn 180,000 yen just to pay 80,000 of that as rent for a one room studio apartment? I think this is absurd, but people continue to pay without complaint. People who own land are able to take money from those who don't. There must

be something wrong here.

By not confronting this problem fully, we lose focus and go back to mindlessly saying things like "Hold on, paying rent is just what people do." That's how frightening "common sense" is. We've become unable to maintain our ordinary basic thought processes.

Let's get real in how we think. "Common sense" is a spell that keeps people from complaining. First we have to break this spell. We can do this by using a resistance method known as "thinking."

Questioning Fundamentally

Even though land obviously cannot really belong to anybody, people think that there's no problem, simply because it's allowed by law. To me, this type of thinking itself is the problem.

Most people think that just talking about it will not bring about change, but I tend to think that there is a good chance that it might. I've been saying this since around 2001 and now, ten years later, finally fewer people are telling me to "stop those foolish thoughts." People have begun to have doubt in their own ways. And this makes me want to continue talking just a little while longer.

Speaking of which, during the last year of his life, the novelist Ryōtarō Shiba[*] insisted on the necessity of de-privatization of land in his book *Tochi to Nihonjin* [Land and the Japanese], and in other writings. Although he did not suggest methodologies for carrying this out, he was nonetheless adamant about it. Henry George, in his book *Progress and Poverty*, appealed for the nationalization of land. This too, I had found to my liking. However, making land into public property isn't my one and only hope. Rather, I want to explore the fundamental idea of how "people cannot possess land."

It wouldn't be an overstatement to say that all wars and revolutions up until now have been fights over ownership of land.

Before we can abolish war, we must first examine the very idea of possessing land.

I have no wish to fight at all. War is absolutely pointless. I only see it as an excuse to prevent people from thinking. It isn't, in any form, a valid problem-solving method. In other words, war is not fought in the hopes of solving an issue. Before I can start calling out for "the end to all wars," I must continue to do what I can and must do.

[*] Ryōtarō Shiba (1923-1996) was a famous Japanese novelist, known for his many works written about historical events.

And that is examining the very nature of land possession.

Sincere thinking about land possession directly correlates to the human question of "what it means to live." I do not wish to argue privatization or publification of land, but rather what I want to focus on is how we interact with our surroundings and events.

Hidden there you will find many hints on survival.

Staying Honest to Things You Cannot Viscerally Accept

I became interested in land during my university years training in carpentry. I became an apprentice to a town carpentry master in Higashi-Nakano, Tokyo, and was to be shown the whole process required to build an entire house. I was involved, starting from groundwork, throughout every stage of its construction.

At the site on my first day, I somehow experienced a visceral inability to accept the idea of pouring concrete into holes that plants had been uprooted and torn out of. It just somehow felt wrong. I wondered how everyone could carry on as if everything was fine?

I became worried and decided to ask my boss.

"Boss, isn't there something wrong here? I mean, back in the day we'd simply lay out some stones and built houses on top of them, right? Why do we dig such big holes and then dump in all this concrete?"

"Yeah, you're right," my boss replied unwaveringly. "There *is* something wrong here."

I never think with my head. I go about my thinking based on my visceral reactions. To this day I've always been drawn by this word "visceral," and consider it an important keyword describing a feeling often ignored. I feel that a "visceral" feeling is on a different layer than that of society which places great importance on the common sense of schools and businesses. I also feel that "visceral" is yet a very common sensation.

I believe that "thinking," first and foremost, starts the moment people intuitively disagree with something. Something that you may be able to mentally process, but are unable to physically digest. This is what triggers my thinking.

So, although I came for training, from that point on I held no interest in learning carpentry and fired away at my boss with questions. How did we come to build architecture in this way? This has to be strange!

At every inquiry, my boss would reply "I know that it's strange." But if he didn't do the work, he wouldn't be able to put food on the table. You can't design structures without an architect's license now, so being a master

carpenter isn't enough. Even if you could, the law now doesn't allow structures to be built without a fixed foundation. Not digging holes and dumping in concrete, means no house is built, when in actuality it's still completely safe without them.

Basically, although my boss was intuitively able to sense the problem here, he was unable to do anything about it as this anonymous system of the architectural world has made this the norm. He understood that there was something wrong. This was what gave me hope; that what I felt was wrong, was indeed wrong.

You must not accept things that are viscerally unacceptable. You must stop this acceptance before it reaches you, and treat it as something that should be questioned. If you allow it to be digested inside of you, you are accepting the unacceptable, and there will be something wrong inside you.

There's No Foundation Under Hōryū-ji

This is how I completely gave up on the thought of building architecture during my third year of university. Since then, for everything that I intuitively felt strange about, I decided to take my time, refrained from getting upset or emotional, and just tried to simply think on it even if no immediate solution arose.

There were also some around me trying to solve these intuitive problems using logic, though their attempts just did not satisfy me. "That just reeks of B.S." I thought.

Adults often say, "well, unfortunately that won't put food on the table."

That's why I decided to prevent myself from doing things that I could not viscerally accept. I chose the life where if I cannot eat, then I cannot eat, and I will deal with it myself. That's why I didn't design architecture and I didn't seek to enroll in employment. I still felt intuitively great and had a lot of fun. I could play guitar, so I tried playing on the streets and found that I could make 10,000 yen a day. That solved it all for me, because I knew then that I would never starve to death.

That's why I decided from then on, to think *intuitively* and *normally*, no matter how old I got.

I felt the same when the accident happened at the Fukushima Dai'ichi nuclear reactor. Lethal radioactive fallout also known as the "ashes of death" came raining down. I wasn't viscerally able to digest this either. I couldn't logically understand what was going on. And I felt anxious about making a move as well. So, for the time being, I thought that I would escape to the furthest seemingly non-chaotic place that I could, and then

slowly think about how I should continue living.

This visceral trigger fired my thinking process. In doing so, it uncovered what it was I must ponder over. Though declaring it my "life's mission" would be a bit too bold, it was clearly some form of necessary task that had been hiding out of view. And in my case, that task was to think about land.

Hōryū-ji[*] temple in Nara—although this is rather obvious—is not built on a concrete foundation. Yet modern architecture cannot be built without one. Thinking normally, there is something wrong with this. Furthermore, carpenters too say that they aren't essential. So why has such an inefficient method become so commonly accepted? After staring at the concrete for a while, the answer popped into my mind.

"Ah, it's to prevent it from being moved."

Although it may seem perfectly normal to most of you, modern architecture to me is a very strange "*fudōsan*"[†].

The Japanese word "*fudōsan*" (which is a direct translation from the French word *Immobiliers*) also started to appear very strange to me. It feels like it is saying "this is your land, and this house is your 35-year mortgage," as if intending to tie you down to it.

When thinking about things like that, the commonsensical, logical thinking process comes creeping back with lines like "I've got to make ends meet." But when this happens, it seems that most people choose the side of common sense without even attempting otherwise.

Apparently people refer to these approaches as thinking logically and economically.

Yet when I approach people about these 35-year mortgages, and I ask them what logical evidence allows them to think that their company will survive for another 35 years in Japan's current state of economic depression, no one has answers for me.

On top of that, if we keep constructing houses at the pace we are now, 43% of all houses in Japan will be vacant by the year 2040. But when I ask people if they would still take out a loan to get a house after hearing that, they get angry at me, saying they've had enough of the conversation.

So I stopped telling them directly. Trying to explain the result of thinking to people who do not think, usually doesn't work out. They say I am a nuisance, and that I should stay out of their business. This world is full of these kinds of illogical actions.

However, we can't give up. We must properly call things out that are

[*] A Buddhist temple located in Ikaruga, Nara Prefecture. Founded in the year 607, the temple's five-storey pagoda is recognized as the oldest remaining wooden structure in the world.

[†] Japanese that stands for "real estate," but written with characters that literally mean "immobile estate."

wrong. So, what do we do? What is the method?

That is my mission.

Are You Happy to Possess Real Estate?

To set the topic back on track, I am viscerally unable to accept the word "*fudōsan*", which first appeared in the Civil Code of Japan, enacted in 1896, as nothing more than a rip-off of Europe (a rip-off of Roman Law format on top of that, which has deep roots in classism). It's these visceral reactions that stimulate my thinking.

And so I begin.

What if I was a king? If people were unnecessarily trying to attach architecture and land together with concrete, then I'd probably stop them. There are many hassles that come along with using concrete, like its undeniable fate of turning to trash, and the inability to be reconstructed. And they construct huge things out of this… In any case I would ban "immobiliers."

But in this country it is mainly immobiliers, and there are hardly any *mobiliers*. Am I, who is the king, the one who's wrong? Suppose you were the king? What would you conclude after simple ordinary thinking? Don't you think this is quite absurd? Why do city halls blatantly give construction permits to things that later turn into so much trash, that cost so much, and that you can't even move?

So, if you simply think ordinarily, it's easy to see that this isn't merely a method for construction. You will see that it holds some other meanings. By laying a concrete foundation, you can fully measure the area of the real estate. And you cannot move a structure from it like one could in the old days of Japanese architecture. The concept of ownership has been materialized in "concrete" form.

We now see that "ownership" is double-layered too. The current government is very crafty when it comes to this. They are using these layers rather skillfully.

Within ownership, first there is the *happiness-in-owning layer* on the individuals' side, and then there is the *obvious-ownership layer* on the side of the administration, which constitutes to their ease in controllability.

The "obvious-ownership" part is easy to comprehend. It's registered on records: people actually live there, they've bought the house, they have a mortgage planned, and that's indeed why they have jobs. It's all easy to see. Now, what about the other; the "happiness-in-owning" part?

What exactly is the "emotion" behind the happiness in owning? I feel that it isn't all that different from renting. Even if you say that with owning comes the freedom in renovating, I don't see people going all-out with it. Besides, I rent and I still renovate all I want. What is the actual sensation you feel when owning a house? What is it like to purchase a house? Is it because you may be able to sell it for more value one day? If this is the case, I'm going to have to inform you that, in fact, it's illegal.

Article 4, Basic Act for Land: *Land shall not be made subject to speculative transactions.*

As a matter of fact, most real estate companies in Japan are committing illegal acts according to this law.

I'm completely unable to understand the happiness of purchasing or owning land and/or a house. If anyone is able to explain it, please teach me. What's the merit in purchasing a house? I can't comprehend. I therefore fail to be an architect, I guess. Because successful architects with their many clients must not have any doubts here.

To conclude, there's no feeling of happiness in owning real estate for me. What's fun is fun, even if I'm renting.

Farmers growing their crops with true care understand and will tell you that they don't consider the land theirs, that they have been blessed with the land, and that claiming the land as their own would be a mistake. All the farmers that I've come to know have told me this.

Being blessed with land suggests the land is not owned. It belongs to neither the ancestors nor the heavens. Basically, it *is* possible to properly distinguish the desire of owning land from creating a house that reflects your "living."

The Hassle is What Makes It Fun

I think that "land posession" is what we must focus on right now. For example, take the commotion over the high readings of radium found in Setagaya, Tokyo in October, 2011. What if that had actually turned out to be radioactive cesium? Better yet, take the disaster currently occurring in Fukushima. Doesn't this perfectly show that real estate can lose all value?

If the current government was really putting more focus on the layer containing "the happiness-in-owning," then they would be promptly helping everyone by providing compensation. But apparently the current government only has enough mental capacity to focus on the layer of

"obvious-ownership," or rather, the layer containing tax collection. That's why I'm concerned. That's why I end up with feelings of distrust.

Basically, while the current government looks at things on multiple levels themselves, they induce people to live on a singular layer. That's the beginning of the mess, and my discomfort towards the concept of ownership. Having a house should be an affordable and fun experience, shouldn't it?

The present form of ownership is heavy and bound by chains. I have fears towards it, but apparently, having fear towards owning one's own house in today's world is considered to be an idea of the insane.

This is where I feel a visceral repulsion towards another matter. A large problem that I have had doubts about since I was younger, and another that I have butted heads with since March 11th, are now unexpectedly meeting on the same layer.

Since the disaster, I have talked about radiation in the media, in the architecture industry, the art industry, and in all other realms of the arts. But everyone avoids the subject and will divert the conversation. There's no way this can be okay. Talking about land ownership with architects is no different. It always ends with "well, there's nothing we can do about it." While this is something that cannot be left untouched in my opinion, it seems that they have kept their jobs by not answering these questions. Basically, it's accepted in today's architecture industry to "not go there."

When you think about this phrase, everyone tries avoiding "there," because going "there" slows down work, and going "there" leads to contradicting what's been said up until now, so we hesitate. I beg to differ. The fact that things are challenging is what makes it interesting. I can only think that the challenge implies a necessity for tackling these issues.

The problem of land ownership is the same as that of radiation. It's not that they don't talk about it because it's not a problem to be talked about, but people don't talk about it because they consider it a hassle. Both issues are a pain in the neck, but we must be able to grasp them if we really think about it. Even if we can't find a solution, we must be able to learn from it the skills to survive.

It's not that there's no problem, but referring to it as a problem proves troublesome, so we just *pretend* that "there's no problem." Pretending to not see something is to "close the lid on something foul." This occurs in all fields of work, including labor, architecture, politics and everyday life.

By taking a look at your surroundings, you come to realize that you're surrounded by this type of avoidance. To me, that's my trigger for "thinking." It's not baggage for me, it's "treasure." It shines bright when you

polish it.

2. A "Public" that Comes Seeping Through

A Fascinating Garden

THIS WAS back when I did fieldwork on gardens in Tokyo for the magazine *ecocolo*. Keep in mind that Tokyo has no place for gardens. I walked around finding gardens grown by people determined enough that they had to have a garden in the city. I named them "4D GARDEN"s.

There was one garden that particularly caught my attention.

First, take a glance at the picture below. This is a garden in Nakano ward, that belongs to someone who had no land to grow it. What I thought was a flower bed, turned out to be the hood of a car. He needed a parking space but wanted a garden as well, and what came together was this.

I wondered what he did with the car. I thought maybe he only used it as a flower bed, but it looked too clean for that to be the case, so I asked the owner. He told me to return the following morning. When I did, it looked like this [next page].

Every morning the owner would carefully remove the pots and take the car out, only to drive his son to Nakano station, a mere 500-meter drive. It isn't even a distance that requires driving, but he says that it's needed for the car to keep running properly.

As soon as he comes back from the station he sets up all of the pots onto the car again. Though it must be a lot of work, the proud gardener did it all with a smile. But the amazing part about the garden was that it was done at the cost of zero yen. In other words, he has never bought a single plant. Whenever he spots an interesting plant along the side of the road he picks a piece. He then plants it in a small pot and lets it grow. It grows new roots, and takes off. This garden was the result of such diligent work.

When I asked where the small pots were, he said "over there" and pointed to an apartment on the other side of the road. Looking across, I saw a row of small black pots alongside the wall like those seen in a flower shop. It was a sort of second-roster farm. After growing here for

A fascinating 4D garden spotted in Nakano, Tokyo.

This is how it looked the next morning.

a while, the plants then move on to flourish in the major leagues: the hood of the car.

"I'm impressed that you have an apartment on top of having a house," I said.

"No, that's not my apartment," he replied.

The apartment owner had noticed the gardener's green thumb and offered to make a deal. "You can use my space too. You just have to keep it in shape as well."

It was head-hunting in the garden leagues.

A DIY Public Park

After seeing this garden, I started to think quite a bit about the idea of private property. You make a garden on your own property and it flourishes over boundaries, all the way across the street. This would not be the case if it were kitchen scraps or strange ornaments, but plants make it possible. Because plants enrich people's hearts simply by being there. Plants have the ability to cross over layers of land ownership.

I took a good look and noticed that in the soil of each pot were little tags with the plants' names on them. Thinking that maybe wide variety of plants grown had made it difficult for him to remember each of the names, I asked, "but why on every single one?" To which he replied, "because many people stop to take a look and almost always ask the names of the plants." The tags were there for the passersby.

The gardener went on to tell me, "there is a public park near here, but the ground is all gravel, and there are only a few lonely trees. You just can't relax there. A park is supposed to overflow with greenery like this happy garden here."

My eyes watered up. What I had thought was a garden, was actually this gardener's do-it-yourself public park. It wasn't a garden-like private space for only its owner to enjoy. Obviously, this was a "public space.": a DIY "public space," hand-made by a gardener.

I decided to call public space made from this method, as shown in this example of the garden, a "private-public."

Those in Japan know that public parks in this country oftentimes don't really have anything going for them. While Yoyogi Park and Inogashira

Park are comfortable, most small parks in the city make you think "Wow, what a disappointment. They just wanted to use up the funds."

They need to take a look at this gardener. By himself, for zero yen, he has made public space on a totally different layer by simply tweaking his own area. I now show this and confidently brag to the world that there is an amazing park in Japan. This is a big ray of hope. And a thought process that we must learn from as well.

Making the Human Body a Starting Point

I have strong doubts about how public facilities are being made today. Things like new libraries, new theaters, and new "interactive" community centers seem to appear out of nowhere. I won't say that we don't need them, of course, but we already have existing public facilities, despite their age, and it won't cause any problems to not forgo building more of them. Besides, they are usually huge in size.

And what's worse, you can't even lie down for a nap there. If that's the case, a simple grass field would be a much better fit. It would mean that we have access to a much bigger space anyway. A public facility that you can't enter at night, and that you can't even eat your *bento* [Japanese boxed lunch] in, can't really be called a space for the sake of its people.

In this fashion, the modern public facility only creates frames. It makes only box-like entities. Whether needed or not, the head of some municipality gives an order, to which an immense amount of tax money is poured into, and a structure is completed before we know it. And as buildings continue to pop up, we in actuality lose spaces to freely play in. The architects' pay is a certain percentage of the building cost so they inevitably try to make as large a building as they can.

Basically, these public facilities are oxymorons from the very beginning.

In comparison, take a look at the public park that the gardener made by hand. He made this garden, this park, as if it were a spreading fragrance that wafted from his own body. It is a public concept that originates from the human body, slowly and steadily spreading outward from there.

This is public. I want to just scream it out loud. This "private-public" is what real public is. It is creating public that people need, not through spending money on the public facility building industry, but through building it packed with devised ideas, even contributing our own space if need be.

I see this as the true human stance on public mentality.

I wish to learn from this example myself.

Let's Make a DIY Government

Here is another example of a different situation: an example of reusing a public park made by the administration. In this case, a playground slide was turned into a zero yen house. Located under a raised expressway in Nagoya, the park is sandwiched between two main roads so you never see children playing there. But still, there is this huge slide.

The resident of this zero yen house has quite an ironic sense of humor. For he quickly made—in a nonviolent display of disobedience—a structure on a different layer in response to the lying administration, which claimed to have built a playground for children when in reality just wanted to use up tax money. What a move.

This way of thinking that I call "private-public," isn't at all a new concept of mine. It's an idea that has subtly existed all around us for some time now.

It's just that when you put a name to the concept and take another look, you find that what may have seemed like a common city street at first glance, is in fact a three dimensional space woven with many layers.

I put this thinking process of "private-public" to use in the "new government" that I started after the nuclear disaster. Putting up with a pathetic park is one thing, but a pathetic government is another matter. It's just no good. So I took a hint from the gardener and decided to make an original government as a private public, and attempted to make my own fun policies.

In the same way that I thought, "what the hell kind of a park is this?", I thought "what the hell kind of a government is this?" The government was only thinking about using tax money, just as they did for that park. I truly and honestly felt—just as they ignored how we may want to relax in parks—that they weren't thinking one bit about people's physical wellbeing nor their lifestyles.

They are disregarding *life*, I concluded.

But complaining alone is pointless; there wouldn't have been a purpose in interviewing the gardener. I had to take action. The answer was simple. The gardener made his own DIY park because he was unhappy with the existing ones. I was

A zero yen house that converts a playground slide placed under a highway.

unhappy with the current government so I made my own DIY government. Perhaps I should mention that being too simple is my strongpoint as well as my drawback.

Just like that, I decided to form a new government.

3. May 10th, 2011, The Birth of a New Government

The Moment of Realization

ON MARCH 15TH, 2011, I learned from reading the Nikkei newspaper that iodine and cesium were discovered in the air even in Tokyo[*]. Dropping everything, I put my wife Fū and my three-year-old daughter Ao on a bullet train to Osaka, and at 8:00 a.m. in the morning I too left for a film shooting in Nagoya. I soon left for Osaka as well.

I spent about a week in Osaka from March 16th, and was behaving like I was crazy. I dialed up every person listed in my cellphone and told them to evacuate to Western Japan. I continued to tell people to flee in the online diary on my website as well.

It just so happened that NHK[†] was filming a documentary on me at the time, so I requested that instead of talking about me, I wanted to explain to the citizens about cesium and iodine. I insisted to an Asahi News[‡] employee, who I had been on good working terms with, that I really had to talk about the ashes of death. We had a serious conversation that lasted until 4:00 a.m. but it was no use. I was completely denied in all my negotiations.

I ended up also contacting a secretary for a member of the Democratic Party[§], and insisted that the Japan Self-Defense Forces be deployed to evacuate people from Fukushima. When I did, I was told "Listen, there is nothing more that can be done using existing methods." At that moment, my eyes were opened.

In the midst of saying we should build Mobile Houses, when faced with a national crisis, here I am, mindlessly turning to the government and mass media, basically trying to rely on authority. What am I thinking? Mr. Suzuki and the gardener would laugh at me right now. I got to do it myself.

When reflecting about it now, it seems like a gag, but I was really serious.

[*] At the time, the media reported that iodine and cesium were only present in the north.
[†] Japan Broadcasting Corporation; Japan's national media.
[‡] Asahi News is one of Japan's largest news sources.
[§] Founded in 1998, ruling party of the national diet at the time of the Fukushima disasters.

I really wondered what there was I could do. I took a glance at the people in media, architecture, and the arts, and though some of them touched on the disaster and others called for "no nukes," I felt that none of them were really taking a serious look at the situation in Fukushima Dai'ichi power plant. They weren't helping anyone flee the area. People are the priority before the pros and cons of nuclear energy. People are the priority before worrying about the next forms of energy. We have to get them away from the scene of the accident.

Birth of a New Government

I was shocked to learn afterwards that the family of a Japanese Diet member, who my wife knew, had fled overseas on March 15th. It's not that the government didn't know what was going on, they just didn't say.

Since the government was not telling people to flee, everyone was left to gather information elsewhere and draw their own conclusions. Since I couldn't fully put trust in any source, I decided to go to the furthest place I could, which was my hometown in Kumamoto. By this time, the senator's family had already fled the country. "That's it," I thought, "Trying to fight with the government on their own anonymous layer is going to kill me."

The government knew, yet made no attempts to inform us. In other words, the senator's family's "lives" and our "lives" were separate, and our lives were considered this anonymous thing that they could ignore—and get away with it. If this is the case, then there's no use in getting excited over trying to make change in the same frame where politics is carried out. I thought that I must make not only a home on my original layer, but a new government as well.

Can you really trust and believe such a government? Yet even after everything, some people may still say "Well, just make sure you inform us next time!" I perceive this as idiotic. This kind of situational dynamic reminds me of a victim of domestic violence who is unable to break out of the cycle. The current government really has it easy, don't you think? No citizens get angry at them when they lie.

I became convinced that a government that does not tell their people to flee when they know they should, is no longer a government. Basically, we are presently in a state of anarchy. Yet it's probably a bit risky to have no government at all, and so in this case I thought I would create one myself.

This is how the "new government" was established on May 10th, 2011. And since I had started it, I took responsibility and inaugurated myself as "founding prime minister of the new government." Why not?

However, in order to prevent coup d'états, insurrection is a punishable crime in Japan. Claiming a "new regime" may not be such a good idea in the eyes of the law. So I decided to call it an "art project." I'm not being untruthful in any way, since "art" is what I always called the act of "changing society". On my tax form, I write all of the expenses that I have used towards my new government as "art production expenses." You may find yourself in a legal trap if you're not careful in these areas, so please watch out. I also requested guidance from my international lawyer friend, and the mayor of Bowen Island in Canada, Jack Adelaar, just to be safe.

Street Dwelling as a Model

Just because it's a new government, doesn't mean I carry out every administrative action. The one I thought I should take charge of, is defending—with my very own life—the right to survive. I am partially poking fun, but no one does this, so I will.

The concept that stands as the main pillar of this new government is quite simple. That is:

"To do all that is physically possible to eliminate suicide."

Dying from the hardships of everyday life violates the constitution. That is the very reason I want to act. Because the fact that street dwellers exist in the first place implies a violation of the constitution.

What I'm keeping in mind is the lifestyle of the street dwellers living in zero yen houses. Here, a world where one can live for zero yen has been actualized. A new economy has been realized where all forms of trash are transformed into currency, where original skills are made into original forms of "currency," and then circulated.

When I speak of this, there are people who say "I don't want to live like a beggar," "I don't want to live in a shack," or "no way am I dumpster-diving for leftovers," but I'm not saying they should live that way. I'm saying that we ought to create ourselves a new layer in the city from zero, in which to make a new lifestyle. You do the decorating in any way you like.

The New Government's Evacuation Plan

The Prime Minister's official residence of the new government is an 80-year-old house in Uchitsuboi, Kumamoto City. It has an area of 200 m^2. I rent it for 30,000 yen a month. I named this place the Zero Center, and made it an evacuation facility for those fleeing eastern Japan, escaping from the ashes of death. Accommodations and utilities were zero yen, which made it a very unusual evacuation center from the eyes of society

(and of course it was mistaken for a new kind of cult...). However when you think about it normally, it's a completely natural act to help people in need free of charge. So I decided it was only natural and never did take a single yen from anyone.

In just one month, over 100 evacuees from eastern Japan stayed here. Eventually about sixty people ended up moving from eastern Japan to live in Kumamoto, where they originally had no connections at all.

Since the official evacuation zones were unclear, naturally it was almost impossible for the administration to properly carry out an evacuation plan. However, a small "personal government" easily can. This is a very practical function of the new government. What is needed is not a large government to rule over the entirety of Japan, but rather a small government that can be facially recognized and easily communicated with. A large government cannot offer this, and will topple over.

My concept has not changed a bit from the time I was researching the street dwellers and making Mobile Houses: that is, to take a close look at what is considered impossible in an anonymous system, and then discover an original layer in which to attempt to actualize things in. It's faster doing it on my own, than leaving it all up to the government. Since it's an "art project," there's no need to pass it through the senate. You just do it.

After that, the people who fled to the Zero Center all moved out and decided on their own where to live. After explaining the attitude behind carrying out our evacuation plans, they were no longer suspicious, and I came to understand that it really got across to them. Having doubts about people in the first place is a necessary act of survival. All you have to do is have a proper talk and solve any misunderstandings. What's more important, is the pure and visceral action of helping one another without considering loss or gain.

What the current government was doing was absurd, I thought. That's all it was. I thought about what a government should have done, which was to properly call for an evacuation. I had no large sum of money, so I was unable to provide the funds for people to evacuate, but I did tell them, "You can stay here for free. We'll think of how to relocate together!"

It's simple and possible enough with the money you may already have. In actuality there were hardly any expenses when it came to the evacuation planning. I took care of the utilities and the travel expenses, and had those incoming from Fukushima measure their contamination levels using a whole-body Geiger counter. Since rent is only 30,000 yen here, maintaining this space was not difficult.

The Very First Diplomacy and Cabinet Forming

As I was doing this, the policy adviser directly working for the governor of Kumamoto Prefecture, Mr. Taisuke Ono, showed up at Zero Center. This became the very first diplomacy of the new government. He even had an interest in Mobile Houses. He said he wanted to use it to change the current concept of residency. I told him I wanted to change the current concept of labor through it as well. This is how my diplomacy with Kumamoto Prefecture began.

I looked into the Montevideo Convention on the Rights and Duties of States, the law that defines what makes an independent nation, and decided to implement this law. The treaty states that the necessary factors of a nation are: 1. Citizens, 2. Government, 3. Land, and 4. Diplomatic Ability. I have 1 and 2. As for 3, I am using the previously mentioned ownerless piece of land I found in Ginza. And 4, I am currently practicing with Kumamoto Prefecture.

Since I have become the Prime Minister I am now supposed to form a cabinet. I first called up Shinichi Nakazawa, a cultural anthropologist and scholar on religion. I met with him in 2010, we hit it off and he told me to "keep on asking childish questions." I had come to revere him very much.

I appointed him to be the Minister of Education. He expressed his acceptance in an instant.

I proceeded to appoint Hitomi Kamanaka, the film director who taught me the truth and the terror of radiation exposure, to be my Minister of Health, Labor and Welfare. Architect Ryūji Fujimura was then appointed to be my Minister of Land, Infrastructure and Transportation. As for the Chief Cabinet Secretary, I appointed the music writer Ryō Isobe, someone I have worked with on my internet radio station for many years. At my own discretion I went on to appoint a variety of friends as my Ministers.

The person who eases any atmosphere just by being there becomes my Minister of Ease. The person who is good at massages becomes my Minister of Massage. The person who is able to find anybody's phone number becomes my Minister of Phone Numbers. Everyone has their own special ability that becomes their very own mission.

Basically, I appointed all of the citizens of the new government as Ministers. I then told them that, though I am the Prime Minister of my new government, I am also a Minister in their own new government. I have no particular desire to rule and control a nation. I am nothing more than a person who—like that gardener in Nakano who made a park out

of his own private space—founded a new government with my own body as the starting point.

Even so, I still dream of putting a full-page ad in the newspaper for the new government. As of now (April 2012), I have 12,000 followers on Twitter. Having a full-page ad is merely a matter of money—all that's needed is to pay the 1 to 10-million-yen price. If I raise about 1000 yen per person, seeing an ad like this wouldn't be so farfetched:

"What Minister are you? The New Government Needs Your Unique Abilities. Call Now! Prime Minister of the New Government, Kyōhei Sakaguchi tel. 090-8106-4666."

Zero Yen Summer Camp

Following the evacuation project, I planned the "Zero Yen Summer Camp Project" to invite fifty children from Fukushima to stay in Kumamoto for three weeks for free. I started this with the representative of the NPO Seinen-kyōgikai [Youth Cooperative], Tsuyoshi Uemura, who has been volunteering in Fukushima after the accident, and the policies advisor of Kumamoto Prefecture, Taisuke Ono. We made this decision, just the three of us, during a cabinet conference. We decided to try it without charging a single yen from the participants. We had no idea if this was possible, but decided to go ahead with it anyway. There were practically no local bodies carrying out a plan like this. The ones that had been carried out were very short, only lasting about three days/two nights.

Return trip airplane and bullet train tickets alone cost quite a bit. For the time being, I had planned to put up 1.5 million yen that I had (This was half of the 3 million yen I earned by selling one of my art pieces to a patron in Vancouver—the other half having gone to my wife), but three Twitter followers, who had come to know of my zero yen summer camp plan, wired a total of 1.5 million yen into the new government's bank account.

This money is not a donation. I consider it an investment that was made towards my attitude. When I declare taxes, I include it as my income and not as donated funds. By doing this, I am also able to express that the new government is fundamentally my work that I call "art" (does that mean that my entire cost of living would be considered as expenses for my new government?).

I call this form of economics, where a desired action is brought to reality simply through the display of one's attitude, "Attitude Economics." This is a form of economy, unlike previous monetary or capitalistic economies,

where the trade and monetary transactions between people are based on their attitudes. It's also an economy inspired by the lives of street dwellers. It's an economy that emerges from the giving and receiving of attitude, instead of emerging from the exchange of goods.

I spoke with people in Kumamoto, asking if any of them would be able to look after any of the fifty children. The children were to be divided into groups and each group needed accommodations, food, and a means to play. Thanks to good timing, I had just started a column in the local Kumamoto Nichinichi newspaper which allowed me to get the word out about the project. I received a lot of support from people which made the zero yen summer camp project a reality.

To tell the truth, nearing the end of the summer camp on August 15th, which also happens to be the anniversary of the ending of the war, I fell into a period of depression (I'm diagnosed manic depressive by a psychiatric hospital. I don't think of it as a disorder though). But the summer camp successfully came to an end without incident. Help from all over came in support of what began as a simple thought; that if there were children who needed help in Fukushima, something needed to be done about it.

During this time, administrations were unable to take any action. There were a few local bodies in Kumamoto that said they would take in children from Fukushima, but none of them actually did. I think the current government is missing a screw. It is simple. Those with even a small amount of capability take action and offer their aid to people experiencing troubles. It has nothing to do with the over-exaggerated notion of ethics or charity. It's simply a very normal act.

As I will explain in the next chapter, I learned this in Nairobi, Kenya. If there's someone who has money, the person who doesn't can relax without worrying about food. And in return, even without money, they can offer great dancing and singing. They can also teach, and become the entertainers of the party. The roles of each person actually become set in this fashion naturally.

This was the natural state of the community I witnessed in Nairobi. I want to implement this Nairobian attitude. It feels very good. It's about moving according to the groove. When there's a good flow, you stop thinking about the likes of money, and just move. This type of scene draws the most people. And to venture even further, it draws in money as well. And great food. That's why there's no reason to worry.

Expanding the Concept of Private Possession

I'm not saying that the concept of "private public" is to make everything public. You could also say that everything is private: that everything is a private possession.

For example, I want you to remember the street dweller who declared "this house is only the bedroom." He took the elements of his everyday "living" and blended them into the city, deciding that his single tatami mat sized house was nothing more than a bedroom and that the entire city was his living room. He expanded upon the concept of possessing private space.

This expansion is bound to drastically change the way we think about our future homes and future lifestyles. You need your own space. I agree with that. But that can be made possible in a different way than owning land. And you can obtain a larger space on top of that.

Possessing is not the issue. Our current concept of possession is limited.

If you completely separate the private and the public, some of what exists between the two may end up lost in the process. As I proceed with my new government, I gradually come to realize that the two concepts may be part of the same idea.

CHAPTER 3

Trade by Expression, With Attitude Your Currency

1. A New Form of Economy

Night in Nairobi

In 2007, I participated in an exhibition held in Nairobi, Kenya.

This opportunity came up unexpectedly. An Indian artist, who had remembered seeing a copy of my photo-book *Zero Yen House* at a bookstore in Japan, went on a search and found me. At that point there were only three weeks remaining before the plane left for Africa. There was hardly any time for vaccinations so I just took a yellow fever shot and got on the plane.

Their request was; for me to find trash and turn it into something that moved. In response, I asked to be taken to the place that had the most trash. I was then taken to Kibera, one of the largest slums in Africa.

I had youth from Kibera work as part of the production staff. They all had jobs, but only making 3,000 yen or so a month. My pay was 70,000 for the three weeks. It's a ridiculously small amount when compared to my usual living expenses. My wife laughed at my pay, but even so, it was an amount over 20 times the normal monthly income in Kibera. Naturally I covered all of the staff's meals.

Two staff members would have been enough, but there were about eight or so by the time I noticed. And every day after work we went to either a club called Nairobi 2000, or a restaurant where live Congolese music was played. Everyone danced the whole time, without even drinking much. And they kept teaching me their native song and dance.

Observing this community of eight, I saw that one acted as a "leader" and received funds from the administration for them to perform as puppeteers. Another who had a car acted as the "sub-leader." The rest were carefree and full of innocence, and didn't have much money at all.

However, one of them was good at singing, another was an incredible dancer, another had good eyesight, another was a skilled artist, another was widely known and was good at connecting people, another was popular among the girls. Everyone had their role. No one gave a second

My "Kibera Bicycle" piece from this stay.

thought about money; the unspoken rule of thumb was "the person who has it, pays." That felt very pleasant and natural.

Observing and experiencing this Nairobi way, I felt the future. They were puppet performers and making money was not a big priority. More important to them were the hip movements in dance and showcasing their skills by intentionally skipping a beat. Understanding this, the girls would gather. I remember thinking to myself, "What an advanced culture."

Although I didn't have the phrase "Attitude Economics" in mind at the time, I must have felt the concept in a seedling form. Peter, whose audio visual equipment was all stolen, had replacements in hand a mere week later that the community had found for him. The leader Tommy did the paperwork every month and was able to obtain money.

As I watched Tommy, I thought of the phrase "money farmer." Tangerine farmers harvest tangerines. Rice farmers harvest rice. Authors write and painters paint.

However, those farmers, authors and painters exchange their products for currency. Everything is converted to money. While it seems quite normal, it also felt odd to me for some reason.

But when I saw Tommy and his friends, the money existed as more than just an element that could be exchanged for goods: it was more like a song or a dance. Just like a tangerine farmer, Tommy was a money farmer who would go and harvest money. He would show up and share it with everyone.

My experience in Nairobi was intriguing, and accordingly, my thought process eventually led from "what is architecture,"—which stemmed from my studies on the homes of street dwellers—to "what is currency," "what is lifestyle," and "what is community?"

What is Economics

The toughest thing to deal with in the anonymous societal layer is our reliance on money in the exchange of goods. And the common counterargument I get from tweeting about "Attitude Economics" is "that wouldn't be possible in today's economy since money is so ingrained in our system."

Let's think about "money." What I think is important, although it also relates to how homes should be, is to first be able to visualize the amount of money needed to support a lifestyle, and to then figure out a way of earning this money within your own layer.

During the Fukushima nuclear accident, there was an argument made against evacuating. Some claimed that people should consider their loss of employment upon fleeing: that if they fled they would lose their income and be unable to support their living expenses. This argument may initially sound logical, but what good is being able to pay for your "living expenses" if you are unable to survive. You end up trapping yourself in a paradox, for how can you weigh your living expenses against the act of living?

So what exactly is economics?

Let's start with the origin of the word.

Economics = *oikos* + *nomos*. They are both ancient Greek words.

Oikos means "household expenses", "place to live", "place in which a relationship is held", etc..

Nomos stands for "custom", "law", "social ethics", and also referred to certain administrative division of ancient Greece. Nomos refers to how oikos ought to be. It could also be referred to as the smallest measurement of Oikos.

Looking at it this way, it seems as though we may have been largely misinterpreting economics all along. Basically, when you reach back to the roots of the word, economy really means the act of thinking about "how to support your household," "what is a household," "how the community should be like where I live," and the act of trying to make that a reality. In other words, it's the action of trying to transform society. The act of trying to transform society is what I call "art."

Wait a second, so does that mean art = economics?

This may sound like something to do with an art-based business, but that's far from the case. Doing business in art only means to use art in this current economy where money is the main medium. This is no different than selling paintings in place of cars. The act of art that I'm talking about cannot be sold. It is the act of thinking what the concept "economics = household" means.

It's not "art = car," but "art = economy." Therefore, "art = the act of thinking how your household should be" and "art = the act of thinking how a community should be." To break it down even further, it means to think about what it means to sleep and to talk to people. To act on the results of the thinking = to transform society = to break away from the pre-existing

anonymous societal system and to find your own original layer.

As a result of thinking about economy in this fashion, what I found was that layers exist inside of economy itself. And that the monetary economy that we believe so much in now, is really nothing more than a single form of economy. A capitalistic economy is the same. In Japan right now, there exists a capitalistic economy, however there also exists an economy realized through the street dwellers reusing the "fruits of the city," or in other words, the trash that we throw away.

I think that building a new economy is exactly the necessary skill in order to go about living from here on out. It's also the reason that I've created this new government.

And so, the new ideal economy that I've been led to is what I call "Attitude Economics."

To put it simply, when a person is willing to try and change society for the better, even if it's just a little bit, then people in society begin to mutually support that individual's wellbeing. This is all that I'm promoting.

I've never received an award and I don't need one. I don't belong to a gallery and I don't need to. No one gives me money on a periodic basis. I don't need a salary. I have practically no desire to buy anything. Instead, I involve myself with society. I act in a way to transform society. I actively participate. I make use of the good in everyone. Those are the things that I have made into my career.

It's not a job that I call labor. Rather I recognize it to be my mission.

So I'm not motivated by money. One shouldn't relate earning money to transforming society. Even so, I do receive money from those who'd rather not see me starve to death. That's enough for me.

I'm raising my three-year-old daughter with my stay-at-home wife and I have my own home and office. We moved to Kumamoto after evacuating Tokyo, and for that I've lost many opportunities for finding work. But I'm still living. I'm not hungry. In fact, my earnings have doubled since Tokyo. Living in the countryside costs less, so I am now able to afford even more. Due to this affordability, I have also been able to spend time on this new government which many don't consider a generator of income. I feel I have no problems.

Money is there for the sake of everybody's enjoyment. That's what I think. I want to use money for enjoyable purposes. Enjoying meals with everyone, inviting guests from afar, planning and executing events for people to gather—is there really any other use for money? At least, for me, there isn't.

The Image of an Attitude Economy

The image that I hold for an Attitude Economy might, for example, look like this: people just walk, talk, and give each other high fives.

That is how the economy is built. That's because, in this image, we have very comfortable homes, towns and communities. That's exactly why people are able to trade intimately with each other.

A person approaches from yonder. There is a light rhythm to his/her walk and it feels nice. There's something cool about him/her and a nice breeze blows. They aren't stiff, but rather very easygoing; they think about how to transform society to be more enjoyable rather than focusing solely on making money. They fill their minds with absurdly innovative ideas that astonish people. That is Attitude Economics.

Basically, Attitude Economics is "living."

In the world of Attitude, who-knows-who is irrelevant. Attitude is something that can be clearly sensed, and if people happen to share the same goals and aims, then they are already fellow colleagues in this economy. So, even if the word "please" abruptly appears, it's met with a "bring it on!" and work starts right away. This is because they are showing their attitude. After displaying your attitude for a long time, there's no longer a need to discuss things, is there? It starts right away. This is Attitude Economics.

If you are short 500,000 yen on funds, then you might be met with a "Don't worry about it so much. I've got an idea to make your project even more fun and interesting, so hear me out and tell me what you think," and before you know it, someone else will have found merit in your idea and would be in favor of investing 3 million yen into your project, allowing you to do even greater things.

In these situations, money is your friend. You mustn't treat it or follow it as if it were your own master. Just high five the money, like a friend.

It may seem like a dream or fantasy, but the street dwelling experts that I have come to know were able to make this economy function perfectly.

Mr. Suzuki, who has been living along Sumida River for over a decade, built not only his own house, but the houses of the people around him as well by using materials he had found. This was, of course, done for no reward. After all, paying for people's actions with money is not a custom that has existed since times of long ago. The act of being told "I want you to make it" is far more important.

Being needed is the very skill necessary in order to "live." If a person in

need gets sick, it causes problems. Therefore, people take care of that person from day to day. That's what a human relationship is. It's not a matter of whether that person has specialized skills or not. More importantly, it refers to whether this person is someone others would want to be with. That's the case with children. Children obviously aren't just troublesome beings that need to be raised. Just by being there, children bring liveliness to the community. At times, children make mistakes. But nobody is irritated by it. Rather, it provides a healthy laughter to the community.

As can be seen, each human being has their own unexplainable unique abilities.

The fundamental concepts in Attitude Economics are being able to perceive each other's qualities with an expanded sense of perception, sharing them, and using them to help each other.

Basically, I'm stating nothing but the obvious.

These aren't new concepts at all.

Helping Each Other Out as a Given

Besides making homes, Mr. Suzuki made electrical systems for others as well. Those who had only a candle, were then able to use an electric light bulb by flicking a switch. Of course there's the convenience factor, but Mr. Suzuki was afraid of candles leading to accidental fires. He had acted in order to prevent this.

It's normal for people who live in close vicinity to one another, even if they aren't acquaintances, to care about and to help each other when in need. That's just acting normally. However, nowadays if you do such a normal act, you're called strange and told to mind your own business. My desires during the evacuation proved to be an example; I wanted to help out, but my plans were often confused with the start of a new cult.

In this age, when people arbitrarily gather, it's thought of as a new cult. This is very interesting, I thought. There are no longer places where people gather without a purpose. Some people make fun of new-age type cults, but I'm no longer able to make fun of such things ever since this experience. They exist because people desire a place to gather.

In this fashion, a community formed around Mr. Suzuki. That doesn't mean they were a collective entity bound by strong ties. They seemed different from a hippie commune as well. They each live by their own principles. But, they help each other. They're just doing the obvious.

However, the experience of having their own house built for them seems to have been quite irreplaceable. Ever since then, Mr. Suzuki has

never faced any problems. Everything he needed instantly appeared before him from his surroundings. If he needed food, a convenience store lunch box would be dropped off. If he wanted to drink tea, then it would be tea, and if coffee, then coffee. If he was in the mood for karaoke, someone would appear with a karaoke machine they found.

This is how Mr. Suzuki realized that "there is nothing you cannot find on the streets of Tokyo."

This of course would be impossible for him alone. But for the Sumida River community, that thrives on the pure trading and giving of skills, nothing is impossible. They each make use of their own skills and each collect their own original trash as if it were treasure hunting.

Mr. Suzuki was unknowingly practicing Attitude Economics. On top of that, this was made possible in the middle of Tokyo, a place recognized as being engulfed in capitalism. I think Mr. Suzuki's way of living, where he managed to make an economy running on the simple act of "living," is the epitome of both economics and art at the same time.

The "I Don't Need a House, Money, or Anything" Attitude

Here's another interesting story.

There's a homeless man named Mr. Satō outside of the Shinjuku Station east exit. In his case, he has not even built a house so we will call him homeless. He operates on quite an advanced form of Attitude Economics. In his case, by making his attitude to the world something completely opposite from ours, he is able to perceive Shinjuku as a concrete jungle rich in resources for him to live. He said he has lived as a so-called "bum" for nearly 20 years. Basically, unlike Mr. Suzuki, he does not work at all. He doesn't do anything. He built no home. He has no money. He says he doesn't need anything. I asked him why and he said,

"There are 'fruits' all over Shinjuku. All you gotta do is pick and eat."

By changing your attitude on living, you make a jungle out of a cityscape like Shinjuku where one normally cannot survive without money.

He says he uses the floor of Shinjuku Station as his place to sleep. It seems that he isn't much of a sound sleeper anyway. Apparently he also takes naps at different locations throughout the day like a cat. That suits his body better, he says. Due to this, he doesn't need a house. I often wonder if it's alright to call people who say they don't need homes "homeless." Sometimes I feel that we, who jump to the conclusion that we definitely need homes to live in without really thinking about it, are the strange ones.

What does he do for food? There are many buildings in Shinjuku that

are filled with bars and restaurants. He knows which ones are in an environment that allows him to come and collect thrown out food. He has ripe knowledge of which establishments get rid of what ingredients. Even fish and meat are easily obtainable.

He has no problem with food nor with a place to sleep. That's why he says, "I have no need for anything more than this, so that's it for me."

Basically it's possible to live with the attitude of needing no home or money, even here in Japan by completely shifting the attitude towards your own "living." I feel that this is also another form of Attitude Economics. Let us notice that there are countless forms of lifestyles in the city.

He went on to say something even more interesting. He says that even so, after all of this, money is necessary. I sort of felt relieved, thinking "I knew it!" So I of course asked him what he needs it for and what he said surprised me even more.

He sticks his hand in and digs for change in vending machines every day. Apparently he is able to make a steady 500 yen a day. So what does he buy with the money he says he has no need for?

"Coca Cola!" he replies.

He lives by his principles: no drinking, no smoking, if you're a beggar—life isn't something to intoxicate. Even luxuries don't interest him, and yet he says Coca Cola is the only habit he cannot kick. Apparently you cannot find Coca Cola on the street. It seems that he has raised the white flag towards that diligent company.

Basically, the 500 yen for him is not a currency that is to be exchanged for anything, but rather, simply a Coca Cola ticket. I was shocked by this comment. While I had been contemplating over what currency was, Mr. Satō had completely morphed the concept itself. These pieces of metal called coins are not currency, but rather mere Coca Cola tokens. Not having money, to him, does not mean he cannot survive. Not having money only means that he cannot buy a can of Coke.

You won't die even if you cannot buy soda. You may be a bit discontent, but what can you do?

Just another form of Attitude Economics in its many forms of existence.

Trading Instead of Exchanging

Attitude Economy isn't intended to replace nor abandon the monetary economy. It simply exists on a completely different layer than that of the anonymous system. It's a sense of economy that is much more abstract, yet a very tangible one at the same time.

An Attitude Economy is not where something is exchanged using material currency. It's not an exchange, it's a trade. Trade, because it's important that it be a trade of attitude involving human feelings and intellect. It isn't simply an exchange.

What I imagine is a scene in a marketplace during the Medieval period. There are two merchants. One has gold and the other has black pepper. These two seemingly unbalanced things, pepper and gold, were exchanged in trade back in the day. How was it done? The person with the gold is better dressed and seems to be more powerful. Negotiating waters seem rocky.

However, the merchant with the black pepper first brings it before the gold merchant and gives him a smell. He then grinds it between his fingers and shares the rich scent. The gold merchant, now close to being overpowered by the "art" of the pepper wants to have some at all costs. But he cannot hand over gold so easily. Gold holds a very obvious and common value.

The pepper merchant then, as if to give the final blow, drips some olive oil in a pan and lights the flame. He then starts to cook some meat. He then simply needs to sprinkle some of his ground pepper on top and the game is over.

The gold merchant hands over all of his gold in exchange for the black pepper.

The exchange is done through the combination of gestures, speech, glistening of the eyes, and value of the material that each person provides. That's what I call trade. These Attitude Economics are based on these types of trades, and will certainly be the pillar of the new economy to come.

I've directly experienced this through the actions of my new government.

It's not enough to carry out trade over the internet alone. The human body is necessary for trade. Accordingly, Attitude Economics will inevitably stimulate and encourage people to move about. It will stimulate direct contact and interaction between people. Of course, what keeps them connected may as well be the Internet, however, by two people directly meeting one another, the currency of unique individual talent is exchanged through physical gestures and motions.

Today, I work not only in Tokyo but in Kumamoto as well. In Tokyo I have media related work such as publishing, and in Kumamoto I have administration related work for the new government, and even in Vancouver, Canada I work in the field of contemporary art. Most of my income is

from Vancouver. I have done work in Nairobi, and a few European countries recognize my new government to be a performance art piece. In Singapore, now in the middle of an economic bubble where land prices are sky rocketing, I've been received as an architect who can actualize a lifestyle free of living expenses. Through doing trade in this fashion, I've noticed that I'm being seen in different lights according to different regions, and they all represent buds of future possibilities that are present to me.

Attitude is not like a completed piece of art. So there's no danger of you being perceived through certain fixed-formulas. When you publish a book, it may be written by you, but writing is not the only thing you do. Of course the pieces and products that represent your thoughts are important, but it's also essential for you to continue to move and show your attitude towards living. You need to physically show where *you* are coming from, and to continue thinking about your own lifestyle.

That's how you build your own economy, a way of "living" to come.

Building a City Inside Your Mind

So how does one go about creating an attitude? Of course, since it's a stance on life it's something that comes about naturally. But in order to make it visible, I started "building a city in my head." We could even call it a "concept city." It's where you actually craft a city in your mind as a city planner would do, based on your own variety of concepts, intentions, tastes, and trials. When you're trading with someone, you invite them into this concept city and converse with them. It may sound strange, but this is actually how I continuously create work from zero.

The experience I had when I was a little boy plays a big part after all. But that's not everything. I also have to thank my professor and mentor from my university years, Osamu Ishiyama, his perspectives on architecture, the Fuller domes that the hippies were making back in the 1960's, Stewart Brand who had introduced the Fuller domes in his 60's magazine *Whole Earth Catalogue*, Jack Kerouac's novels, and Thoreau's book *Walden; Life in the Woods* which are all to me "literature of economics." This all connects to Kamo no

My "concept city" of 2005.

Chōmei as well. Furthermore, I can mention Kumagusu Minakata's view on space in his *Minakata Mandala**, the idea of a fourth dimension proposed by those—mainly Poincaré—in the 1900's, as well as Picasso, and Jarry. I'm also influenced by the connections I've found between the poetry of Raymond Roussel and one children's play I saw in my childhood. There are many more on the list.

I create a city space in my head based on the variety of thoughts and concepts that I have.

To me, the conversations that I have with others are equivalent to visiting and trading in each other's concept cities.

2. Two Worlds Called School Society and After-School Society

My Friend Doi-kun After School

How DID I come up with the expression Attitude Economics? I'm greatly influenced by the households, lifestyles and communities that I have experienced up until now. Basically, my economic experiences gave birth to this idea of "Attitude Economics." I would now like to try and look as far back as I can and describe these experiences.

When I was in first grade I had a friend named Doi-kun. He wasn't very good at studies, but he was amazing at crafts. When we had homework over summer vacation, he made something incredible. It was a kind of coin bank that, when you put in your one yen, five yen, ten yen, 100 yen, and 500 yen coins, it would send each coin down a different rail towards its designated stop. In each holding zone the coin bank would tally up the total amount of money by measuring the weight of each type of coin, and would then show it on a digital display. I was in complete shock. All I had made was some analog robot out of snack boxes. I was shocked at the utter difference in construction. I truly felt that I was an unskilled shallow human being and I wanted to be able to build like Doi-kun did.

However, Doi-kun wasn't good at school work. So even if he built and brought in these amazing crafts, he received little recognition in the "school society." I thought this lack of recognition was strange. This was because he properly lived in the "after-school society."

Isn't it the free time and the after-school time spent working at home,

* A Minakata Mandala is a diagram of the cosmos drawn by Minakata Kumagusu (1867-1941)—a Japanese author and naturalist—in a letter to Doki Hōryū(1855-1923), a leading Buddhist scholar and priest of the Shingon sect. The diagram shows that the universe is made up of countless numbers of causes and effects, and many realms intersecting in different points.

that we should really be putting our efforts into? I decided that I would put effort into making high quality works during this after-school time.

The quality of Doi-kun's skills, which could only be measured by the people who could understand it, appeared very rich in value to me. It was a solid value. No matter how bad the test scores were or how clumsy he was, his crafting skills were as solid as a rock. The value of Doi-kun, who made that digital coin bank, had a certain polish that shined very brightly.

School Society and After-School Society

At the time I felt that there were two different worlds in this society. The "school society" was where everyone was expected to do the same things, and the "after-school society" was where Doi-kun's true realm was. I felt as if these two were woven together into school life.

Since I had a rather unusual perspective on things, I decided to go about life being conscious of these two layers. I thought that the school society was nothing to make fun of either. It is an anonymous layer built by the subconscious. It is *The* System. School provides everyone with the same exact things. It's a game-like society where you are evaluated by passing levels. It is a game with no exceptions to the rules.

Hence, I decided to give this "studying" thing a try. If you "play" school as if it were a game, it can actually be fun. Since things that do not appear in the textbook do not appear on tests, all one has to do is memorize what's in the textbooks. That's how I interpreted studying. So every day I read aloud, went through with a red pen and crossed everything out and memorized it. You can get by in most "school societies" like this.

I also decided to test the waters in the after-school society at the same time. From first grade, I began drawing a comic series called *Monomono-kun* where various stationery items were the main characters playing out a story in a kids' room. This series was a bit too "sweet," so I also drew a die hard series called *Muscle Man* which was a rip off of *Kinnikuman*. And I secretly drew erotic ones as well.

I drew every week and when I had a good amount I compiled my work into a magazine series called *Hop Step*, in the hopes that it was just one step away from the famous *Jump* comics. It felt good to see the bound booklet grow thicker. It's intriguing to remember that publishing was my first endeavor. It was done very simply of course; pencil drawn and stapled together. It wasn't done through memorizing steps. I had to make everything work on my own instead.

I also mimicked Sanrio goods and made my own line of products called

Sakario. I made iconic characters modeled after a cricket and Son Gokū, and created letter sets and plastic calligraphy mats and went around selling them off to the girls. They were all complete imitations but I got excited over the actual making of them. I hoped for these days to go on forever as I did school-society homework in between projects.

Continuing this flow, I began working on transferring NES (Nintendo Entertainment System) games onto paper. I made an RPG that was seemingly a fusion of both *Dragon Quest* and La Salle Ishii's *Child Quest*. This was a serious hit. I felt like I had become a Nintendo hard disk. Observing things from peculiar angles became a habit of mine.

I would go home and play baseball with my younger brother, keep records of the games and made a league tournament (details can be read in my previous book *Tokyo Hitotsubo Isan* [Tokyo One-Tsubo Heritage]). It was fun to create an entire imaginary society in a baseball game. I was so excited to later find out that beatnik author Jack Kerouac and Japanese writer Tetsuya Asada did the same thing. Everyone wanted to create a society, I thought.

When I was assigned to be in charge of the school paper, I grew tired of doing it for the school society, and therefore started my own newspaper. I wrote my own regular novel corner and drew the pictures to go along with them.

Then I finally reached the conclusion that the after-school society was the one that I really wanted to live in.

Furthermore, this after-school society, unlike the one-dimensional school society, holds a vast variety of possibilities, different for every person. Doi-kun and I were fellow after-school society members. We just aimed to actualize different societies. We could coexist though. On the other hand, school society was trivial, bland and boring.

Countless After-School Societies

I'm starting to realize that perhaps I'd been doing the things I am writing about now back in my elementary school years.

This includes the fact that society has a layered structure, and the fact that the anonymous layer which is a collective of the subconscious, is easily misinterpreted as the only layer. It also includes the importance of creating your own unique layer. All these things were always vaguely on my mind.

When you have your own unique layer, similar to that of the after-school society, it's easy to create new work for yourself. Even when I,

someone who just drew comics, rebelled against the school paper committee by publishing my very own newspaper, nobody complained. My parents hardly ever bought me new Nintendo games, so I couldn't keep up with the conversations in school, but since I was making my own then the other kids became wrapped up in mine.

This doesn't mean I am saying that school society is all bad. When people live together, there must be some degree of rule, even law. Also needed are game-like challenges that everybody must clear. People that want to clear these challenges because of the game-like nature will appear as well. I thought the school society was boring but I didn't dislike it.

Therefore, when I think about the new government now, I often reminisce about my days in elementary school, or more specifically, about school society and after-school society. I'm very conscious about these two concepts as I go through life. There's only one type of school society, but there are as many after-school societies as there are people living in them. There are not only two layers; there are countless layers.

As I've said many times, school society is the world belonging to the subconscious. It is the anonymous layer. This is the societal system. You can even say that it's like the infrastructure strung up around the cities. This layer and the multiple original conscious layers are folded upon each other like a layered cake. That's the world we live in.

We must move past this "adolescence" stage of society, just as the philosopher Immanuel Kant suggests. We must perceive the subconscious and anonymous societal system layer, properly make distinctions, and trade among those living in their own original layers in order to expand society. This, for me, is the "new economy (the ideal community)." This isn't a matter of overthrowing the currently existing system. It's the work of widening one's consciousness.

The reason that people known as "*hikikomori*" refuse to leave home and refuse to go to school is that the anonymous societal system has expanded to the point of losing balance, and people then come to believe that it's the only layer. While these *hikikomori* are producing their own original layers, unfortunately, society doesn't allow for diversity or flexibility.

So how does one make society more flexible? It's not possible just by relaxing. Think. That is it. A thinking society. Let us relax after we've thought. It should feel fantastic. The new government is devoted to making a "thinking revolution." A Revolution of Thinking!

Trade is Impossible When Anonymous

You cannot jump from a school society to an after-school society. That's because school society is a necessary element when humans live in groups, whereas after-school society is a realm of the individual. But you can jump between various after-school societies. This is what I think of trade. You cannot trade when you're in school society. Trade is impossible when anonymous.

Looking at the way things are today, I feel that many are attempting to completely destroy the school society in order to form a new kind. However, that's an impossible task because the school society is not the realm of the individual. School society belongs to the anonymous layer shared by everyone. You cannot change the dreams of others.

School society won't change. The only thing that is up for us to change is the balance between it and the after-school society.

School society can't be erased, yet we can attempt to shift consciousness. That is the act of thinking. Once you realize that school society is just one layer among many, and the only subconscious layer out there, it becomes much easier to keep your balance. In order to do so there is a need for you to expand the view of your after-school society.

I thought in this manner all throughout school. It's just that transcending this school society is quite a difficult task.

I felt the presence of a similar layer when choosing which university to enter. I wanted to become an architect, so of course I wanted to enter an architectural program. In school society, Tokyo University, Kyoto University, Waseda University, etc., are thought to be the best places to go. That's the limit to the information that you'll have access to in a school society. You can't even find out what teachers are at the Universities. No other information is available.

The only thing you know are the average acceptance scores for the schools. It's as if you are being told that you don't need to think. Here, thinking is rejected.

Connecting With "Naked Information" Through Attitude

Even so, we are residents of the multiple layers so we obviously think this is absurd. But we can't do anything about it in school so we have to go elsewhere. This is where the library comes in handy. At a library, all information exists randomly and at equal importance. Therefore, your thoughts and attitude come alive in your method of choosing information, which becomes the matter of importance.

What I did, was I read every single architecture related magazine at the library. This random order of information becomes very important as only your attitude can prompt an interaction with the available material. Attitude can allow you to interact with the bare, or "naked information". So I looked through every magazine, but they were all completely boring. I looked through one more time, and then I at last found one person who caught my interest.

His name was Osamu Ishiyama, and he was creating extreme architecture. This wasn't information provided by the school society layer; it was the kind that leads a person to their own layer. He taught in the architecture department of Waseda University, so I decided to apply there. And this was when my scores were far below what was required. Luckily, however, an application for specialized acceptance based on an essay and interview for that very school fell into my lap one day. And even more luckily, the people around me in the school society layer were all aiming for Tokyo University or Kyoto University so they didn't even notice that option. Hence, there were practically zero applicants. This is how I was able to enter without even having to take an exam.

But even before I was accepted, I thought to myself that despite whether I got in or not, I would still be fine either way. I thought that, even if I wasn't accepted and failed the exam, I would still know Osamu Ishiyama. I had already found out who I wanted to learn under, so even if I did fail the exam, I would just have to go to Tokyo and slip into his lab. University lectures are easy to audit without permission anyways. In fact, studying in that fashion seemed like it could be a beneficial experience, so I couldn't have cared less about entrance exams.

I think this is also an act of Attitude Economy. Although no money is made by this act, I still consider it to be Attitude Economy. Economy isn't a method of making money. It's the structure of a community, the type of living arrangement, and way of life. It basically refers to the way you live.

Before we can express our attitude we must first perceive and recognize. Knowing is a must. Kant says to "have the courage to know." And so, once you know, you must hop off the automatic and anonymous train track and hop onto a bicycle. Of course it's the first time you will ride the bike, so you will fall. There's a need for you to learn how to ride.

You mustn't feel down after falling a few times. Most people are able to ride their bikes by now. They are able to because they fell a few times. Is there really anyone who can remember *how* they learned how to ride, or the times that they couldn't ride? The best bet would be that you have long

forgotten those days of not being able to. Once you get the hang of it, you forget the part of you that wasn't able to do it.

Of course the act of thinking is necessary on this layer. However, just as I have mentioned many times before, you must not forget the school society, in other words, the subconscious anonymous layer or the societal system. There are people out there who hope to escape this system, but that's just not possible. Society rests on its very existence. It's basically like the surface of the earth. It's currently covered in asphalt. Now because it's asphalt, it makes it hard to breath, and truly, I too wish that the societal system and the asphalt would crumble and become uneven soil, but that seems a bit too difficult.

One must not crawl along the surface of the earth either. It's too slow and it deprives you of the scenery. That's why you must ride through the subconscious world on the conscious bicycle, using your own unique methods. That bicycle is the after-school society, and your original layer. Ride to the next town on your bicycle. Go touring with others. Collide. This is trade.

Unsigned Money and Signed Money

Having ended up at University, I now existed in the school society. Conscious of this subconscious world while being in it, I made my own layer and exhibited it. I decided to act in this method. It was an experimental period for Attitude Economy. Declaring my original layer while in the school society was done through creating pieces that fulfilled the school assignments, yet could be exhibited long after. I must say that it was a rather simple and childish idea. I've mentioned my works from my university years in other published material, so I will refrain from elaborating on their details here.

After graduating, I did the same thing during a part time job at the Hilton Tokyo. I was a waiter in the Marble Lounge, on the first floor next to the lobby. I took orders and catered on the customers. I never liked part time jobs very much, but I loved meeting new people so I actually liked this work.

I liked the hotel as a place as well. The very existence of hotels is also a form of Attitude Economy. People wish to stay and pay money for the hospitality that the hotel offers.

Even though it was a café, it was also the hotel lounge, so we weren't there primarily to serve coffee. At least that's how I interpreted it and began thinking that everything was allowed as long as the customers relaxed

and enjoyed themselves. When you do this, you begin to win the affection of, say, a nice old widow who lives in a room at the Hilton.

After a while, I was beginning to receive more and more tips and at one point I was even receiving the same amount as the wages I was earning. I became very interested in the two amounts of money, the 250,000 yen in wage, and the 250,000 yen in tips. They were of course the same 250,000 yen but they were as different as night and day.

The monthly salary was "currency" that was anonymously paid according to the amount of labor. Tips, on the other hand, came decorated with the time and the scene of receiving them, along with the customer's character integrated within each of the bills. It was a bit different from just any money—this money came with a "signature." Since it had a signature, it was almost like a piece of artwork.

I eventually began to think that if I were to earn money, I wanted it to be signed money. This later became reality when I began to sell my works of art. As you can see, there is very important information in the anonymous school society and the "part time job society" when it comes to making one's own original layer.

Clothed Information and Naked Information

There are two types of information, "clothed information" and "naked information."

People are easily swayed by clothed information. In my experience, I often find that the conversations with girls wearing fashionable clothing are rather dull and uninteresting. A fashion sense is simply a bricolage of "clothed information." I suppose it's partially my fault that I'm lured in by what's on the surface in the first place...

"Clothed information," as the name depicts, wears clothes. In other words, it is information that exists with the intention of being seen by people and is "information that compromises with others." Of course, it's very pleasant to look at, and has the ability to get along well with a variety of people. However, this information does not affect *social change*.

The effect of social change is impossible to be brought about while compromising to suit the expectations of others. Others identifying it as something familiar is the basis of this compromise, but in this situation it is impossible to affect social change or to broaden perception. On top of that, since clothed information gets around so well, people often misunderstand this aspect.

Even so, this doesn't mean that one should go around behaving absurdly

doing things that no one can understand. As previously mentioned, since we already exist on this subconscious and anonymous layer, we must not ignore it. However, we must not compromise our actions either. Keeping this balance becomes very important.

Again, as previously mentioned, many people have the tendency to take "social change" to mean replacing an already existing society with something completely different. But this is also incorrect. Social change means "social expansion." It's not enough just to discover one's own original layer. One must trade with it as a basis. This is what expands society.

Expanding society is the act of interpreting "naked information" in one's own way, making an original layer and trading with that layer as a basis. In this process, Attitude Economy seeps through as if it were a lubricant. It doesn't happen in the act of making some new "thing," but rather in the act of encouraging others to think. The fact that that person is living, encourages others to think.

What is "naked information?" It refers to the information that you find after undressing clothed information, one item at a time.

To continue with the previous topic, statements like "going to university is just what you do after graduating high school," "Tokyo University ranks as the best and Kyoto University is the second best," and "you must take an exam in order to enter university" are all examples of "clothed information." They don't appear threatening to anyone. But, they are illusions created by the preconceived notion of society being that way, and make you believe that this information has a solid foundation constructed by the subconsciousness of the people

We must take all of that off, one piece at a time and face the "naked information" underneath. This is because the act of *thinking* lies beneath. As long as we are unable to realize this, we will never be able to reach the thinking process for taking action ourselves and making a new economy.

In other words, the way in which one undresses information becomes their attitude.

This is because it becomes obvious as to what you are able to allow and what you cannot accept.

In my case, I undressed information by wondering "where's the need to go to university?", "why are schools considered good or bad just based on the grades?" or "why do people choose their paths of study solely on the school name?"

First, before choosing a university, I was able to encounter naked information. I thought, "What kind of architect do I want to become? I have

to find someone that can be that model."

The way of facing information, the way of taking off clothes, and the "how" of taking off clothes is all deeply tied with your attitude. At the same time, it also faithfully shines light on the intensity of your thinking process.

Police can't arrest you for the public undressing of information. Take 'em all off!

3. My Attitude Economy Documented

I Practiced Attitude Economy from the Start

IN 2004, I published my first book at the age of 26. I had been creating pieces of work up until then as well, but this was the first time I expressed my thoughts publicly to the eyes of society. My attitude towards my work hasn't changed at all since then. I would like to take this opportunity to discuss how I went about publishing the book, and what methodologies I used to proceed with my works. I think that I may be able to better explain what Attitude Economy is and what it will become.

In 2001, I graduated from the Architecture program of the Science and Technology department at Waseda University. I hadn't participated in any activities towards job hunting and therefore was obviously unemployed. I considered myself independent rather than being unemployed though. I believed that the time had come for me to live out life, and declare my thoughts to society.

But I didn't know how. I didn't even have a grasp on what kind of work best fit me, let alone any connections. Although I called myself an architect, I absolutely had no intention of building architecture from the start, yet putting my thoughts into published material was not realistic for me at the time. I had no skill in order to do so. I had big dreams, but as for how to put them into reality, days went by without me being able to find any answers.

Of course, my work towards this was generating zero income. So I spent every day distraught and working a part time job at a fruit store in Tsukiji, Tokyo. In my hand was a 200-page hard cover book of my research on the homes of street dwellers. I submitted this book as my graduation theses and it received the highest praise in the whole lab. When I wrote my graduation thesis, I tried taking a look at a variety of essay formats, but they all lacked a strong intention of wanting to be read and I felt no attraction

to them at all. So I did my research by looking at photo-books. I decided to make a book that I could show with confidence wherever I went—one that anybody would want to publish right away. That was the type of book that I wanted to create and went ahead in making it happen.

So I created a photo-book like you might find in a modern art collection. I printed out and edited each picture that was color copied at 7-Eleven, wrote captions below each one, pasted them on Kent paper, and used numbered stamps for the page numbers. In this fashion I made something that could hardly be called a graduation thesis, and was more like a work of art that would pleasantly surprise anyone laying their eyes on it. From this point on my work had begun.

Leave What You Don't Understand to People Who are Good at It

After working in Tsukiji for a while, things had settled down, and I thought of publishing this graduation thesis. But I didn't know anyone in the publishing industry. I hardly even knew the names of any publishers. I thought of looking them up at a bookstore, but being an outsider, I was still absolutely clueless.

So what did I do?

I decided to look for the person I knew who had the most knowledge about books. It's most efficient to seek aid for something from the person who is good at that something. That's what I thought at the time. I only chose books and music from what other people had recommended. I knew I had no taste when it came to choosing things. I have good intuitions but terrible choosing skills. So I decided on having someone who was knowledgeable about books decide for me the publishing company I ought to pitch my book to.

I had a friend from high school who read a lot and would tell me about the many interesting books she knew, so I decided to show her my book and have her choose for me. When it comes to this, there's nothing to do but to show the work and leave and entrust the rest. This would become one of my working methods from then on. As it turned out she became the Coordinator of Publication Minister for my new government.

After a while she came up with an answer.

"More than likely, you'll only be able to publish it through the company Little More."

It was a simple answer. That moved things along. I called the publisher right away. However, the publishing market was in a slump. There was no way they would put out a photo-book by some unknown Joe, let alone one

about the homes of homeless people. They hung up on me with hardly any reaction at all.

But one mustn't give up, so I called back. My friend told me this was the only place so there was nothing else to do. I called again, having only the trust in my friend to depend on. I was told that it was the end of the year and that they had no time to put up with me. So I asked them when exactly they would have time, mentioned that my friend told me I would only be able to publish my book through Little More and would love for them to take a look.

They then told me that they would have some time early in the following year and we decided a date for me to go and pitch my book.

I brought it in and they decided to publish it right there, although it did take over a year for the actual publication.

Negotiating the Contract with the Publishing Company

Since it was my first time publishing anything, I had no idea how to go about it. I had a friend who was taking pictures so I asked him and he said that the cost of publishing photography was high and that it doesn't happen very often. Many photographers even split the production costs with the publishers, he said. Well I did *not* want to do that. A publishing company with that kind of attitude would never go out of their way to help sell a book, and since they really liked it, I would not stand for them giving anything but their best to cooperate and show respect.

Little More liked my work. And at the same time, they liked me as well. The president Mr. Kahō Son also told me, "You young man will become someone great one day." Of course I thought that I would be doing amazing work someday too.

I was a beginner at publishing books but on the inside I was already the Prime Minister of my new government. So I felt that I couldn't sell myself short. I thought that I could not allow for a vertical relationship with the publishers, and that it was necessary to make an even and fair relationship.

They informed me that it would cost too much to print 200 pages of full color and that the price of the book would be 3,300 yen. I was told that it wouldn't sell at this price and that the book would be a risk for them. I decided that if the royalties were to decrease then my position with the publishers wouldn't be fair.

I had learned from my friend that since the cost of a photo-book is so high that the publishing industry's common percentage of 10% royalties often decreases to 6%. I didn't want this, and felt that I shouldn't divert

from how I had always previously done things. So I said:

"I am a beginner, so you can have all the royalties from the first batch of 3,000."

In these situations, it's a hard and fast rule to take the first step. Although it wasn't exactly a show of appreciation for their decision to publish my book, I told them that I don't need the royalties of the first print, which ended up coming out to about 900,000 yen. There was no original risk on my part anyway. I was happy for it just to be published.

But this was the thinking of a beginner. I thought that if I make a deal based on the thinking of a beginner then I would always be a beginner. This cannot happen. So I added:

"Although if it does sell, I would like to have 10% royalties from the second printing on."

The president agreed to this deal. He was the guy that said I would become great someday. He understood right away.

The Strategy of "No Retreat"

In this way, by making the royalties of the first print zero, I was successful in maintaining my attitude. For me, this is a very important method of making contracts.

By making the royalties zero, it made it easier for my demands to be met. I had decided this book would probably not sell well if it were sold only in Japan, so I wanted to add English translations and send it out to the rest of the world. I went ahead and proposed this, using the zero royalty in my favor. I was going into this already with the conclusion that my work would someday be read by people all over the world. If the book was not of that standard, there would be no point in publishing it.

But the publisher's face clouded over. Of course translations cost money too—just as they should. They said that a 200-page translation would cost way too much for them, and declined. Most people would give up here. But I had this fantasy-like confidence that one day it would become a piece of work to be read throughout the world and therefore refused to back down.

I often use this strategy of "no retreat." When I say strategy, I mean a strategy against myself. Humans give up too easily because they get tired. But you're unable to fulfill your mission like that. It's necessary to pilot yourself. That's why you make a situation where you can't retreat.

So I asked them how much they'd be willing to spend on the translation. I was sure that a publisher would want works translated if they had

the chance. I was answered with a surprisingly low figure of 50,000 yen.

What did I do then?

I gave them a smile, took the 50,000 and hurried right out of there. Basically, I decided that all I had to do was find a translator myself. Luckily at the time, my brother, one year younger than I, was studying French Literature at Aoyama Gakuin University, Tokyo, so I was positive that there would be someone there aiming to become a translator. I called him and told him:

"Is there anyone in the English department who wants to become a translator? The pay is 50,000 yen. But I'll credit their name in my book. Naturally it will be distributed overseas. I need it to be done within two weeks and preferably with a native speaker's final check-over as well."

These were the conditions. He had someone in mind and asked them right away. The reply was positive. In just a few days, I was able to find someone who would translate it for 50,000 yen. The fact that I was able to achieve this through the publishing company, something mostly seen as a chunk of the rigid system, gave me hope since I had always relied on my own will instead to make things happen.

Doing My Own Pitches Abroad

The story doesn't end there. Now that I succeeded at adding English translations by making my royalties zero percent, I asked them to leave the overseas sales up to me. The publishers were very surprised. Of course the topic of plane fare came up. Albeit partially for business, I took it as a chance to go to many countries as well. Since I would pay for the flights myself, I asked them to let me do as I please.

As one would expect, since I was covering my own expenses, the publishers accepted. So I took my book and flew straight to Paris. I visited every art and architecture related bookstore. I even went to Centre Pompidou National Museum of Modern Art. I was able to experience many different people's reactions. Paying, not for travel, but for work, is one of the most enjoyable things. You have an objective. You have a reaction. You have new encounters. I charged on and on ahead. I even appeared in London.

Furthermore, I met with a curator of an art exhibit in Paris and we even agreed that I would enter some work in an exhibition. In Japan, nothing works smoothly unless you are famous, but I found out that in Europe, the nameless yet innovative are the ones that are valued more. After that, I went home once and then flew myself to the Frankfurt Book Fair, the

world's largest trade fair for books. I asked the printer Toppan Printing to display copies of the book at the fair as I ran around visiting and talking with various distributors.

Thanks to this, eventually I was able to have my book at the New York Museum of Modern Art and from there I even managed to obtain my own exhibition at the Vancouver Art Gallery. Publishing was the most effective arena in expressing my works in Japan, but I also learned that this differed among each of the countries I visited. In Canada, I was received as a contemporary artist.

I utilized my own unique layer for each contract and refused to sign documents subconsciously. God is in the details. Let your own attitude seep into that area. By doing that, you will be able to spread your own ideas, though little at a time, out into the world.

Since my royalties remained zero, there was also zero income coming from this work that I did overseas. But I didn't mind. I kept my focus deciding that this was the time for me to plant the seeds that would continue to let the world know of my existence.

How Much to Sell Ones Work For

Things kept moving along. When I visited Canada in 2006, I was able to sell a photograph that I put on display during an exhibition at the Vancouver Art Gallery. I thought it was more important to show my attitude than to earn some pocket change, so I donated the entire amount of the piece to the museum. They said they wanted the proceeds, and they had been a big help. However, thanks to this, I was able to learn that there were collectors out there willing to purchase my work.

After that, I handed over various pieces to many different places. If you ask why I did all of this when it didn't bring in any income, it was because I was able to feel the presence of the collectors out there, gathering my work. I was able to confirm that there were people who wanted my works enough even though they weren't valued for large amounts of money. That simply made me happy.

Collectors naturally want to know about the artists they're buying from, and what kind of people they are. One of my buyers e-mailed me and requested that we meet. His name was Jack Adelaar, and he was a very competent lawyer. He said that he wanted to come to my home in Tokyo. (He would later in 2011 become the mayor of an island across the bay from Vancouver and would start diplomatic ties with the new government.)

Jack brought along his wife and actually came to my apartment. I nearly

My first drawing piece that I sold.

passed out when I heard they were staying in a suite at The Peninsula Tokyo, and we treated them with the humble yet proper meal that my wife had cooked. Listening to him express the amazement that my photographs held, I was so overjoyed that I nearly cried. It was as if he knew more about my works than I did.

Halfway through, since Jack had been sitting on a tatami mat he wasn't used to, he said that his legs hurt. I suggested he sit on the bed. This is where a bit of a miracle happened. He pulled something out from underneath the bed. It was a drawing that I made when I was feeling a bit distraught. Upon seeing it, Jack said "this is amazing!" and began saying that he wanted it. I, who had never sold a piece directly, didn't know what he meant at first and was perplexed. Jack then asked "How much?" What should I do…?

What I thought at the time was that it would be nice, if by selling this drawing, that my wife and I could support our household for about two months. Since our monthly expenses came to about 200,000 yen, I put another 50,000 on top of that and doubled it. Although a sloppy calculation, I placed the value at 500,000 yen thinking that this was a price that would support us for the next two months. At the time, I wasn't basing my calculations on how much the price should be according to my career in the world of contemporary arts.

I decided that my drawing was 500,000 yen and told Jack so. It seemed that it hit the price that Jack had in mind right on target and he bought it there and then. He even wired me the money the very next day. This was the moment that I sold my first drawing. I was even more excited than when I received payment for my writing the first time.

Money Can be Fun in its Own Way

I get nervous every time it comes to selling my drawings. You must be firm when it comes to deciding a price. You must think for yourself and you must not include the current market in the decision making process. If I were to consider the current market then my drawings would only be worth 5,000 yen. But I always told myself that if you do that, you will

remain at the 5,000 yen price for the rest of your life—that you must always think of yourself as top-notch.

I feel that people who price their works at 5,000 yen when they are nameless are bound to then price them at something like 1.6 billion yen when they become famous. Attitude Economics isn't like that. Once you say 500,000 yen, it's 500,000 until you die. That's how I live and how I will remain no matter what—even if I'm ninety years old.

Collectors truly observe people, since they deal directly with them. This is pure trade, just like the days of the black pepper merchant. That's why if I said 600,000 the drawing wouldn't have sold and if I said 100,000 the excitement for the purchase would have diminished. Then there wouldn't have been a next time. There's a moment when both sides are nervous. But there exists a value that keeps both parties excited and this is what I call "compensation towards intuition."

Just like the tips from Hilton's VIPs, this money was different from the hourly wages I received at the hotel. It wasn't completely the same though. This money represents "compensation towards intuition," unlike labor wages. It's money that represents the amount of joy one feels towards my intuition as an artist. I think this money that is paid towards "intuition" is something amazing in its own way.

I'm often perceived to be yelling zero yen, zero yen, but I don't actually dislike money. Money is interesting as money. It's just that we have to alter what it's exchanged for. I want to get rid of unsigned money being exchanged for labor.

And so in 2007, I was able to earn 500,000 yen before summer hit. Of course I was still continuing to work at the Hilton Hotel so my savings jumped to 2 million yen. At the time of my wedding in 2006 I had zero yen in savings, but by this time we were finally in a place where we felt we could finally get by. But my works hadn't yet gained the momentum to connect us to the next stage. I had no regular columns, and was still a part-timer.

Keeping the Output Simple

Work always comes from unexpected sources. One day I was invited by Ms. Makiko Yabe, the chief editor of *Aera* magazine at the time. She was the one and only person who, in 2004 when I published the photo-book *Zero Yen House*, admired it and had quickly set up an interview with *Asahi Weekly*. Back then, she had more confidence in my future success than I did, saying "You have something amazing in you."

She invited me out to dinner. I thought this had to mean something. I thought of discussing about the lifestyle of Mr. Suzuki, who I had just met at the time, and I planned out the conversation beforehand. Even if you think of something amazing, without preparation you can't get the idea across well enough. Since I like practicing, I spent time at home mumbling to myself while having an imaginary dinner with Ms. Yabe.

Ms. Yabe, naturally sensing right away the "new economy" that Mr. Suzuki had created, agreed to give me a five-page special on the topic. And I was to be properly compensated on top of that. In other words, she was making a request and paying respect to me as an author.

I was so excited I wrote 20 pages in one day.

After reading my manuscript, Ms. Yabe shared in my excitement. And in the issue of *Aera* the following week, the first manuscript that I had ever written in my life was included almost word for word without revision.

When this happened, I soon received an offer from a publishing company called Daiwa Shobō who wanted to create a book based on what they saw in the article. On top of that, I received another miraculous offer. They said they wanted to make a movie based on the article (this later became the film *My House* which was shown nationwide on May of 2012 and was directed by Yukihiko Tsutsumi). They both seemed interesting so I naturally accepted. I had a hunch that something was about to happen.

I went to Daiwa Shobō and talked to the chief editor. He had previously worked as the editor of *Tomorrow's Joe*[*] at the company Kodansha and seemed very competent. The first words out of his mouth were, "You, young man, are amusing. You could probably write 300 pages like it was nothing, couldn't you?" That was what he predicted. I could not help myself and accepted the offer saying "There's so much I want to say, I might just write 350 pages."

Upon going home, I told my wife I accepted the offer, and declared that "I am going to quit waiting at the Hilton." My wife gave an unexpectedly light "sure, why not?" and though I had never written a book and didn't even know if I could, we officially became completely independent. This was July of 2007. I started my own company and called it *Sakaguchi Kyōhei Jimusho* [Sakaguchi Kyōhei Productions].

At this point I had 2 million yen in savings. No regular columns. No job. Just one request to write a book, and a potential offer for a film adaptation which seemed more like a dream than anything. I had just quit my part-time job and my wife was pregnant. My wife worked as a jewelry

[*] A legendary comic series focusing on the life and death of a boxer.

designer and had quit her work in hopes of going independent. That's when we found out that she was expecting. So my wife's income was also zero. This 2 million-yen-boy, decorated in all kinds of zeroes, went to work slapping a keyboard every morning from 5:00 a.m. and set out on a journey to write 350 pages for his first book.

I had been writing a journal every day on my own website. I wrote in detail about who I met, what I did, what I read and what music I listened to. That was my only media output. It wasn't like my book sold well. My overseas exhibitions had been completely ignored in Japan. But I was writing.

Even though I called it my media output, it was surprising to get even 300 hits a day. But I continued to write regardless. I wrote in great detail so I'm sure my nature got across. After some time, I gradually began running into people who would tell me that they read my journal. I focused on expressing my thought process in detail.

I think the journal writing was also due to my malcontent towards people seeing me only as a researcher on the homeless. I've had seemingly chaotic thoughts since I was young, and had always assumed if I were to express them all at once that nobody would care enough to take a look. So publishing such a book was also the result of acting out on that thought. My aim at the time was "more chaos in my head, and more simplicity in my output." If I put out a book like *Zero Yen House*, then there was the danger of being mistaken as somebody who's only interested in street dwellers. But I did that on purpose, thinking that someday I'd be able to get across complex matters in ways that are easier for people to understand.

At that point I already wanted to do things that would lead to my present work, such as making music, drawing pictures, doing writings, taking photos, and giving talks. But attitude of that nature isn't something that gets across simply overnight. It was necessary to properly slice that four-dimensional sphere in order to show just a segment. The chaos that gets left out in the process is what I tried expressing in my journal. That's how I kept the balance.

At the same time, the journal also became the medium for me to express my thoughts on various matters. It was also a visual medium where people could see and immediately tell that I was trying to work among multiple layers. First of all, I handled it not as an information trading platform, but as a place to materialize my thinking process. Basically, in order to express the degree of my attitude.

Of course, none of it was going to bring in a single yen, but it was good

for my mental well-being.

Make a Plan, Stick to the Routine

Anyhow, I had 350 pages of blank manuscript in front of me I had to tackle. While I had 2 million yen in savings, my wife and I use about 2.5 million yen annually so the savings would not have lasted us a year.

But I didn't fret. In fact, I felt joy that I could pour all of my time into my work. It was a first time experience for me. It was the feeling that I had wanted ever since I was drawing comics in elementary school.

I could focus on my work whenever I wanted, and for as long as I wanted. I felt like I had finally managed to stand on the starting line of society. This is how humans ought to be, I thought, without having earned even a single yen yet. I had the confidence that I had done my share of training though. I realized that six years had passed since I graduated university in 2001. But I thought that this was just right for me, that it was what I wanted to do, and that I should just do it. On top of that I had the confidence that I would be able to make it. After all, I had made it through these six years, hadn't I?

But even if you have confidence, it won't write manuscripts for you. Not a single sentence will get done if you leave it alone. My pregnant wife had a bit of worry in her face. I didn't know how to go about writing but I decided to do it with momentum. I began writing by the seat of my pants.

First comes the scheduling plan. I am a planning monster.

My way of planning is very simple. I make my day's quota about half of what I'm able to put out when really going at it, and continue that for a long period of time. I was able to write a full 20 pages (about 8,000 characters) in one day when I wrote my first manuscripts for *Aera* magazine. So I divided that by two and got ten. The final goal was 350 pages so I would write for 35 days.

I'm a morning person so I can't write at night. I decided to write from 5:00 in the morning without breakfast until 12:00 noon. I could write for seven whole hours by doing so. I decided that I would stop writing right at 12:00. I am easily distracted, so when I over-concentrate on one thing, I find other things I want to do. I use the time after 12:00 to do that.

I wrote every day from July of 2007. I wrote, not up to any certain point in my writing, but for seven hours a day until 12:00 noon, keeping true to the routine. This way of doing it really suited me. Even if there was something I still wanted to write, I dropped everything at 12:00. Stopping according to time rather than workload is nice because the daily routine

decides it for you.

Writing in this way, I realized that writing ten pages a day really was not that much trouble for me. Since I had never written a book before, I wondered why. Then I realized I'd been writing my daily journal! After counting the amount of characters in my journal I'd been writing, it came out to ten, sometimes even twenty pages a day. In total, I'd been writing hundreds of thousands of characters.

It's a journal so each day is connected. And it continues every day on top of that. I may have readied myself to write a novel without even knowing it. That's how I was able to breeze through the manuscript every day. I checked my journal one day and saw that it was August 20th, 2007. I had finished writing the 350 pages almost completely on schedule.

I sent the manuscript to Daiwa Shobō and the reaction was positive. I think it was perhaps something like beginners luck. The editor added a heading, divided chapters and completed the editing without touching a thing other than missing and misused characters. Four months later, *Tokyo Zero Yen House, Zero Yen Living*, was published.

Annual Income Increases Six Fold

After writing in the morning, I would go to work on my drawings in the afternoon. I felt potential after Jack bought that drawing I had done for fun for 500,000 yen, so I thought I would move forward with my drawings as well. I think this was also due to—as I mentioned previously—not wanting to be associated only with the zero yen house. So I drew little by little every day.

Then one day, my friend invited me out to a get-together over drinks. There was an art dealer from Kyoto there and I talked with him about the concept city. And when I also expressed my interest in the concept of space, mixing in talks on the zero yen house, Kumagusu Minakata, Marcel Duchamp and Buckminster Fuller, I was able to grab his interest.

Then when I happened to mention that a guy named Jack from Vancouver bought my drawing, he said he wanted one too.

"It's 500,000 yen. Expensive, isn't it?" I asked.

"I'll buy it!" was the quick reply.

And so, the second drawing that I was only half way done with, sold as well.

The 500,000 yen from Jack, the 200,000 yen for the *Aera* manuscript and the 500,000 yen from the art dealer totaled 1.2 million yen as of September 2007. In a leap, my annual income had increased six fold

compared to the previous year. I hadn't done a single promotion for any of the three. I just met people. Basically I just carried out trade. That's all you need.

Do Not Change Your Attitude

Around this time, a request came from a non-profit gallery in Vancouver, where a trusted curator works. They were going to have an auction in order to raise money for running the gallery next year and said they would appreciate it if I donated a piece of work for charity. Without thinking, I offered them the drawing that I had come to like the most.

Usually at a time like this, no one hands over their favorite piece for free. In actuality, all you see at auctions are few editions of previous works. But I figured I wouldn't stand out if I did that. Even if money didn't come my way, I already knew that there was value in the very attitude of the person liking and purchasing my work.

That's why I sent my favorite drawing to Vancouver. And that drawing also sold, this time for 400,000 yen. Of course none of this money saw my pocket, but I was excited to find out who bought my drawing. The buyer, named Rick, was an Andy Warhol collector!

The lesson that I learned here was that, while you can ignore the majority of no compensation offers coming your way, some of those offers can be truly worthwhile. And when that comes about, you provide your favorite work just like with this auction. Basically, no matter if the value is zero yen or 500,000 yen, you do not change your attitude.

It's not that I'm happy that my drawings sell for 500,000 yen. I'm happy that I'm able to work on a layer where I can decide that it's 500,000 yen. When you confuse this area here, Attitude Economy starts to crumble. I'm on a layer that no matter who I sell it to, it's 500,000 yen. Even if it doesn't see my pocket, I still work on that layer.

When Trade is Carried Out

Attitude Economy is to trade—between things and people brought about by putting your own original layer into action. It is to trade while perceiving the many layers present all across this world with an expanded understanding, and jumping around from one layer to another. This begins with determining your original layer. It's the only way of living on multiple layers as opposed to the current world of hierarchy, the world of superiority and inferiority.

The price that I decided on when making a deal with Jack reflects

nothing about the contemporary art layer, the art gallery layer, the fame and recognition layer, the amount of work experience layer, or the "Sunday painter" layer. The only thing that it reflects is my own original economy layer. I decided that one drawing would be worth about two months of living expenses.

With that said, it doesn't mean that nothing else was reflected. I made the decision after meeting with Jack. So Jack's consciousness is reflected here as well. Jack has his layer too. When a mutual agreement occurs between two original non-anonymous layers, Attitude Economy starts to shine even brighter. This is the trade I speak of.

Even when the anonymous societal system layer that I've been talking about collides with an individual's own original layer, things don't move along that well. This is nothing more than a "transfer." *Trade* occurs when two original non-anonymous layers are conjoined. It is the act of agreement between two original economies (styles of living), through the medium called attitude.

When a curator from the non-profit gallery asked me to offer a piece of art for free, this form of trade took place as well. When I offer my favorite work, the curator will then show it to the most entrusted collector. The piece is then sold for 400,000 yen. This is the value that Attitude Economy gave it. It's not the yen, but the attitude that matters.

On the other hand, in the anonymous economy the piece with the least value would be offered when asked to donate something for free. Rather than that, act according to your own layer of attitude. If it's an auction that you think has value, then you present your most valued piece regardless of the fact that it's for zero yen. People react to that attitude, and Attitude Economy starts.

There's No Need for Understanding Each Other

Even when you receive an offer for a small article, as long as the theme is interesting, you should do your work on your attitude's layer. If the offer is for two pages and you feel you need ten, then you write ten. If they react to your attitude, then Attitude Economy takes action.

But you cannot act on random impulse, because people are generally unable to understand each other. This is why the anonymous layer came into existence.

People, are unable to understand one another. That's why we feel the

need to "read the air"*. This is something that lack of mutual understanding brought about. The anonymous layer, i.e., our societal system, needs something like this "air" to inhale or else it will collapse. An original layer is a vacuum. You can jump anywhere, weightlessly, and trade.

There's no need for fellow original attitude layers to understand each other. Because they are originally two lifestyles with totally different economical systems. However, they are able to feel. Even if they can't understand, they can perceive because their attitudes are exposed. But the anonymous layer isn't like this. That's why there is "air" and this mentality of trying to understand one another.

Other than my first visit to Little More, not once have I pitched my work to anyone, saying "this is what's amazing about it." Not only do I have no need for that, the act of climbing aboard the anonymous layer or that of someone else's, leads to the collapse of one's own original Attitude Economy.

So rather than that, I just met with people. I went outside, venturing wherever I was invited. All you have to do then, is live. You simply show your attitude. The best place in which to do that is "the everyday." You just meet people. Trade. I thoroughly kept up with showing my journal to the public. I continued this all along. It was then, upon reaching 2007, that my Attitude Economy finally started to move.

After making 1.2 million yen, having just finished writing my first book, selling my first drawing on top of that and just barely reaching the point where I thought I would be able to make things work, I started to ponder on how I should go about doing things. It was then that another editor invited me to a café, and when I mentioned the book that I had just finished writing, they recommended that I make a novel out of it, and I accepted their offer (*Sumidagawa no Ejison* [Edison by the Sumida River]).

An editor I met in London requested I write a column in the *Spectator* magazine. This was my first column for a magazine. Similarly, the editor for the magazine *Coyote*, who had been reading my journal, requested a column about traveling by bus. And on top of that, a girl I met while clubbing in 2002 had reappeared in my life as an editor and I started another column for *ecocolo*.

They were each around 20,000 yen a month but I thought it was more important to continue the articles on one theme and accepted every offer. At the end of 2007, I had earned 1.2 million yen, had a finished

* This is a common Japanese phrase meaning to intuitively sense the atmosphere in a certain situation. More importantly, it is mostly used when one restricts or corrects their actions or comments to accommodate to that time, place or mood.

manuscript for my second book, and wrote three columns. I remember rejoicing with my wife, excited at the miracle of making over 1 million yen from my work.

As you can see, I am fulfilling my works in a variety of ways. It is also the materialization of the concept city inside my head. "Attitude" is the lubricant that allows my works to connect and expand seamlessly.

My current income comes from a variety of fields, mainly my book royalties, my columns in magazines and newspapers, the movie rights fee, talk shows, lectures, art museum displays and the sale of drawings. In my case, I could care less about things like titles, and who I'm perceived to be. Above all of that, the most important thing is how I can express the complex concepts inside with attitude.

This is the same method in which the street dwellers of Sumida River were able to make their living space little by little using their own body as the origin. I just need to be me, and make that my work. This is the fundamental principle of Attitude Economy. The attempt at being myself.

CHAPTER 4

Methodology for Creative Works, a.k.a. the Human Machine Theory

1. The Definition of Creative Works

You Cannot Redo Life

I BELIEVE that life cannot be relived. That's exactly why what we do *now* is being called into question. In this crucial situation what should we choose to do? How competently can we stay independent without conforming to our surroundings?

Abolishing nuclear power is fine, but I think that would imply abolishing the government and all the corporations, too. If we don't get rid of corporations, the banks will not collapse, and the government will not fall. Nuclear power plants will remain unless we go that far, and they may remain even then. But can we go that far?

I came up with a quick answer.

Nope.

So I made a new government on a different layer. That's why I moved to Kumamoto. The current government will not fall. It will not change, no matter if the Democratic Party hands over power to the Liberal Democratic Party, or even to the Communist Party. It's not like the United States will change it either. That's why I decided to revolt. A revolt of ignoring. A revolt of fleeing. A revolt of declaring independence.

I think nothing will come about if the young people do not take action soon. Don't think someone else will do it for you, act for the sake of yourself.

Let's pay proper attention. Take a good look at the useless politicians now. Really, during March 11th, the people who could have acted immediately—the financially stable and experienced adults—should have acted. I telephoned all of those people. But no one did anything. I'll never forget that.

The people who were able to properly react to the radiation were either around the same age as, or younger than myself. This intuition intrigues me. I think that may be the key. One needs not to speak of their ideologies,

as long as they can tell that the dangerous *is* dangerous, can inform people that it's dangerous, and lend a helping hand.

There's just no hope without the actions of young people. During the uprising of Shimabara (1637), leader Shirō Amakusa was merely sixteen. Ryōma Sakamoto and Shinsaku Takasugi[*] were both in their twenties. Even if you consider the fact that present-day education is slow and takes longer to complete, our limit is probably our late thirties. The forties and over are for gathering and providing funds and connecting people together. It can only be the young ones taking action.

The youth must think about what a new economy means for them. If each and every one puts that into action, society too will most definitely change.

What We Want to Do is Not Important

At times I am invited to universities to talk to students. They say things like "I'd like to do so and so." Young people often misunderstand this area. There's no need for what you'd "like to do" in society. I can only tell them to immediately leave and go do it at home. You want to live doing what you like to do? What is this, a deserted island? That's not what doing art is about.

Some others tell me "I will now think about what I want to do." Hadn't they thought about it beforehand at all? After properly listening to them, it seems that they think they'll never find what they want to do. That's not it. You can't get by like that.

You must ignore what you want to do, and do what no one else will do if you don't do it. In actuality, this is a function that everyone carries. Most definitely. Why? Well, humans are called thinking reeds, aren't we? We think. What we want to do is not important. We just think. And open our mouths.

When I had decided to be an architect and was studying at university I asked the professors and professionals this question:

"Why do you continue to build this boring stuff?"

They all said they had no choice. I thought, "Ah, these people are useless. I've got to raise my voice and make a change some day."

That's all I'm doing. I'm not doing it because I like it. That won't drive me. My drive is something much sincerer. I thought that we'd be in big trouble if we left everything up to these adults. It may sound like an

[*] Ryōma Sakamoto (1836-67) and Shinsaku Takasugi (1839-67) were both revolutionary samurai of their time.

exaggeration to call it my mission, but I decided in my heart that this was something that I had to do.

These are simple things if you remember the stories from your childhood such as *The Adventure in the Closet*, *My Father's Dragon*, or *The Wizard of Oz*. I wonder why they had been forgotten?

So it's not about what you want to do. That's the first thing I'd like young people to understand. Failing to see this will lead to trouble. Because in actuality, the strange unique individuals barking things like "I'm going to do this!" in their student years often end up doing nothing, speaking up about nothing and hiding somewhere and being scared when they become adults. That's just too sad.

Head in the direction of actualizing a society, rather than trying to actualize a self-image.

Making that decision is the first step.

Creation is Turning Doubts into Questions

What's important is whether or not you've had doubts. If you've had them, you will survive.

Those who have never had a single doubt in their life should go right into the corporate world. Go live following orders. There's no need for those types of people to worry about nuclear power plants. But, if you have a "doubt," then that's a chance. From there, you raise it up to a question. Turn that *doubt* into a *question*. I call this process a completely original form of "creation." Creation, not in the sense of pretty colors in a painting or a beautiful melody, but whether you were able to find something wrong in the world.

Why do I call turning doubt into a question "creation?"

First of all, we are alive. In this society, and in this city. Many people live here. They function in the same system. It seems like a singular layer, and it seems like there's no problem. It seems as if it's peaceful.

However, in actuality, it's not your own system. An anonymous society constructs an anonymous system. If you ask who made it, it was our own subconscious. Without realizing, an anonymous system comes about as we ignore our own personal systems. Of course it's easier that way. Because you can get by without thinking.

But that's not a peaceful system. It ignores some of us. There will always be someone with troubles. But that's tiresome to look at, so a hierarchy is created, and from that, a single system is formed. But since that isn't your own system, you feel a bit uncomfortable. It's a bit demanding, but it's easy

nonetheless.

For that same reason this system can be called natural. I mean, even if it's a bit uncomfortable, we all want ease. If we are able to get by without looking at what we don't want to look at, we can put up with willingly being in that type of system. But you must not forget that this isn't your own system. It was a system unintentionally formed by everyone's subconscious.

Everyone's subconscious has constructed the anonymous system. Things like laws, cities, schools and wedding practices are in fact part of our subconscious. Subconscious isn't a vague concept that can't be seen or touched. It's our everyday life. For most people, that's the subconscious.

"Doubts" arise because the subconscious realm really is a problematic and thoughtless nuisance. "What the hell is this?" We sometimes stop to think. And when that happens it's in the bag. When you become aware of that, the next stop for you is to find someone who is living in the conscious and not the subconscious. It's a feeling similar to being inside of a science fiction film. I tried to walk through the city and meet people from that perspective.

That's how I met someone living in the conscious. It was the resident of the solar powered zero yen house along Sumida River. He was adamant with his doubts, kept his conscious, and went along creating a lifestyle with his own system. If I were to explain it using my terminology, he had created a "new economy," and I learned a great deal from him.

When I did, my "doubts" gave birth to more concrete "questions" such as "what lifestyle can be called a conscious lifestyle?" and "what can be called conscious and autonomic architecture?" My work started from there. I did not think that the book I made based on that experience was "creation." I thought that the very moment of questioning was creation.

I want you to look at the scenery around you like this. Because, far from making things easier, it will make you nervous, put you in cold sweat and make you want to run and hide, scared and on the edge of dying. It's very lonely. But there are people and things that you will encounter in those times. They will give you hints as to what your mission really is. Never mind overcoming your fears quite yet, just try approaching and touching, try even talking to them.

Making an Environment in Which You Cannot Die

It was when I was thinking about subconscious living that I happened to read Kant's *Perpetual Peace*. I realized that he was referring to this concept

as the "adolescence." See, everyone is saying the same thing. Creation is not a "piece of art" that an "adolescent" can easily come up with. I hope that you realize this.

I'm able to think this way thanks to my manic depression. In the manic stage, my body and mind are able to live a conscious lifestyle and I can purely focus on making a new economy, so work gets done. But during the depression stage my lifestyle becomes subconscious. My neural circuit completely shuts down. My world turns grey.

But, I still have memories of conscious living, so when I try to continue living in a subconscious way, I suffer from complications. I become completely detached. This leads to thoughts of suicide. It means I think about suicide 24 hours a day. It's quite agonizing. But even then, I desperately think I need to find a "doubt." The act of "thinking" during this time is the act of finding a reason not to die. It becomes a matter of *life*. That's exactly why one is able to realize that the act of thinking is a very sincere attitude of being human.

It kind of resembles Son Gokū training in strong gravity. You must find a reason even then. "Do not be convinced, connect it to a question," I tell myself. Basically, to me, my depressed phase is my best time for creation. I relate those thoughts to society and the city in front of me, and then I "think" on it. That is the skeletal structure of my works. I would like to show my gratitude to this life-long disorder. I actually don't consider my manic depression to be a disorder at all. One can see that it is a very natural movement of the body. There is no way that this thoughtless society, made up of the subconscious, is comfortable to anyone. There exists much ignorance, discrimination, class division and poverty.

There's no way that this isn't painful. But I have come to realize that my symptom is simply a natural outcome for a natural mind.

That's exactly why I was able to decide that I had to connect it to movement, to action, and to actualization.

That being said, a condition is a condition. There exists the possibility that I might die. That's why I made the new government. When I declared such a thing to the world, I was met with many supporters and now I cannot opt to die.

Basically, I cannot *allow* myself to die.

This means, in other words, "I have to live."

This is what it means to live. It's not about a successful career, or getting into a good company, being famous, getting qualified, getting a promotion or earning money.

"Living means not allowing yourself to die." Make an environment where you must live. *This* is living.

2. Think of Yourself as a Machine

It's Important to Make Conclusions

I HAVEN'T changed at all since my elementary school days. I really just wanted to do something crazy that would astonish people to tears. I wanted to make people remember something they had forgotten. I wanted to call back a delicate feeling that I had when I was a child. I wanted to be independent at all times. Money wasn't an issue. People always made fun of this attitude of mine. I didn't really mind though.

I held on, undiscouraged, and it was society that started to show some change. In other words, efforts get through to people someday.

What we must not forget is that it takes some time in order for Attitude Economy to take hold. It's not some kind of instant thing that you can find at an unemployment office. Attitude doesn't lie. That's why it takes so long. But once it's built, it can never go away.

Okay then, how does one go about deciding their own attitude?

To begin, do not consult anyone. Think about it in your own head. Think only about what you have the mental capacity for. You must not consider the words of anyone else. That isn't thinking. Thought means to ponder only what you've been thinking. Get rid of unnecessary beliefs, get rid of unnecessary knowledge and think with only what you've experienced since you were young.

Then, after you've thought in this way, you will find something that is absolutely necessary: an "answer." People often say that the answer isn't everything, but that the thinking process is where the importance lies. But I think that's all wrong. An answer is most definitely necessary. You must conclude. And that first responsible conclusion that comes out of your mouth—that's the "answer."

I conclude. I make conclusions very often. I'm often told that my conclusions are wrong. But that's not the point. What a person concludes is the display of their responsibility. Those conclusions are that person's "thoughts." That's the responsibility of living as an individual.

Today's society is afraid of making conclusions. This is irresponsible. We are living in an era of social irresponsibility. "This is what I've been ordered to do, not what I chose," government officials will say. Politicians will say

this. Professors will say this.

No wonder they rot. There's no responsibility. No concluded answer. There's no trade.

I thought, this is what needs to change.

That's why I conclude. I come up with answers. I research and investigate as best as I can in order to avoid making mistakes, and in the end I come up with an answer. An answer that can only be come upon then and there. Keeping true to that, is Attitude Economy.

That's why I always accept debates. I reply to the words of any person. No one can tell me not to conclude. That way there's no criticism, no fights, and no getting heated up. You can have a proper debate. You can make critiques.

I want to make a city that's properly critiqued. That's a responsible and restrained society. It is possible to build a society with a broad enough mind to accept when people are in the wrong, one that mutually aids, based upon the premise that people make mistakes.

That's why I don't want to say things like "irresponsible ones should not enter the ring." The world of criticism and the arts, in literature, fine arts, architecture, and even politics, is not true art at all when it's full of people with that kind of attitude. It's boring. That's not how it should be. *You* have responsibility as well, so don't say things behind the scenes just because you may be a student or something. Get out in front and declare. That's what a true artist would do. It's what a person of action would do. I think feeling that way is a form of philosophy. You and I are in the same ring. This isn't a relationship of author and reader.

That's why, if you have an opinion, if you have a serious and responsible critique, I want you to call me or to take whatever measure you can to let me know. If it's my phone number, it's already written in this book. It's on the internet too. I don't hide. I'm always in front of you, smoking a cigarette. I'm always naked. I am naked in the very sense that no matter how I am looked at, no matter from what angle I am criticized, I want to and am completely ready to answer. It's not that I have no fear. I properly perceive and face the fact that fear is nothing more than fear.

The Human Machine Theory

My "responsible conclusion" (or the "answer") that appears after "thinking": this is what I use as a power source to move this machine that I call my body. I "conclude" that that is what it means to "live." As you can see, we run into an endless loop. That's why the energy goes on forever.

Are you able to see just how much of a waste it is to sit by every day without an answer? A lifestyle without an answer has no endless loop so it must warm up it's engine every time. You must fill it with gas and it has bad mileage. It's easy to understand if you think of your body as a machine like this. I think of my own life as something mechanical.

I often do these things where I substitute the functions of my body, spirit and mind to different parts of a car. By doing so I can visualize myself controlling and moving my body, and I can also recognize that the method I use to move my body is fundamentally the same as creating a new economy.

When you leave it be, the human mind turns to chaos. All possible factors mix together and you lose grasp on what caused you to work in the first place. If you think of a human to be an organism controlled by the vague and undefined mind, then your "living" will end up becoming abstract. It is here that we should reinterpret ourselves as a car and begin moving ourselves mechanically and precisely.

In my case, I don't use money as the gasoline to move my body. I've decided to make my engine run without the need for money.

Let me explain that further. I now live with my wife and daughter, but since we don't live for money, it's possible that we will completely run out of it. I've decided that when that happens, I will proudly go to the riverside, build a zero yen house, and live a street dweller's life with my family. My wife is also prepared for this. That's why we don't worry about the money running out. That's why we are able to put 1.5 million yen on the table, from what little money we have, when we want to invite fifty children from Fukushima.

I have designed my body to act even without money. My fuel isn't money, but rather my constant attitude towards social actualization. That's why my fuel never runs dry. It means that once my dream is realized, society will have changed. When that happens, I'm thinking of firmly leaving this work, and focusing my life on nurturing the next generation.

That is to say I am enjoying this endlessly long drive until I've accomplished my mission.

When you are using desire as your engine, it will come to a stop once the desire has been fulfilled. That's why your engine doesn't need to be your own. You can go pick up a fantastic engine and just install it. It isn't necessary for your own mission to be something that you thought up on your own. All the things that countless people in the past have attempted but were deemed impossible are actually often similar to the missions that

you may want to accomplish.

That's how I've crafted this engine of mine named "Mission." I have tuned it by looking up to the thoughts and actions of many others.

With my attitude-fueled engine, I make full use of my transmission to drive on the roads laid by my predecessors while gazing at the passing scenery of the subconscious world.

It's practical to compare the human body to a machine in order to design, maintain, and repair it, and in order to think about how to drive through the experiences of daily living.

There's no Grade to Talent

When you live an assertive lifestyle constantly coming up with answers, you are able to work extraordinarily efficiently. You're able to live.

I am able to write about thirty to forty pages a day, except for when I'm in a state of depression. Some days I write even fifty. Of course the amount of pages is not the point, I mean to say that I have this level of endurance. When I'm on a roll, it really kicks in and works well for me. However, when I'm in a slump, absolutely nothing works. It is for this reason that I do my work according to the pace of my body, and not to a single constant pace.

In this manner you can create a way of "living" or an economy based on what you might perceive to be a disability. This way you'll find out, rather than it being a disability, that it is in fact a methodology to actualize your own unique "thinking."

Think of it as this: instead of everyone living on top of the asphalt and moving in the same environment, we rip up that asphalt and walk freely feeling the uneven surface of the earth.

The reason why so many words come out of me when I'm in my manic state is not because I'm thinking every day about what I'm going to write and say next (I'm constantly threatened by suicidal thoughts). Instead, it was because I didn't want to die that I've been thinking about what it means to live. When I'm in a state of depression a vague purpose or an abstract reason proves useless, so I take a look at my "living" through a high-resolution lens and think in more specific terms. This is how I gain strength. And when my depression clears up, this strength acts like a spring and puts me in a state where I end up needing to write pages upon pages.

To me, talent isn't a thing that one excels at. Talent pertains to the part of us that is able to purely involve itself with society.

Talent has a "melody." There are no grades to talent. It's more like a kind of sound that you produce. You cannot change what kind of instrument you are. But you can improve your technique. We are able to learn technique through experience. In other words, we are able to expand on how we come up with "answers." That is the only thing that needs to change in order to change your very way of "living." That's what makes it interesting and that's what gives us hope.

Economy is what you get when those melodies come together and trade. So get out your conductor's baton as if you were going to lead an orchestra, as if you were going to create an ensemble with the masses, and play your talents for each other in search of that one answer.

Knowing the Right Time to Slack

When you realize that excelling isn't about talent, you can feel quite at ease. Humans need to be more at ease. You might think that what I am saying is contradicting, but it's important to be at ease. Once you're at ease then you can find the time to think of an answer by reaching a responsible conclusion.

The most important thing in life is bringing about social change. When it comes to matters other than that, then the most important thing is for us to slack off as much as we can. Let others do your work if they can. In exchange, focus on social change as if it were the only thing keeping you alive. That's how I managed to reverse the meaning of society's "slacking" and what slacking off means to me.

I mean, people often say that they're too busy with work to do anything. That's not good. When I look around the only thing people are slacking on is in fact the most effective use of their own body; the act of bringing about "social change." And then they say things like "society just doesn't seem to change" without even trying anything. That's not the proper way to slack off. They're merely putting off "living." And then just happen to be serious about most other aspects in life. That's not the way to go. We have to slack off more. We have to know how to take it easy.

Take it easy when you're reluctantly employed by a company that tells you to work hard for money even when the ashes of death are falling outside. You've got to slack off. However, we must not slack off when it comes to thinking about what we can do for the children in Fukushima that are being exposed to the ashes of death. We need to think diligently. In this way, we should gradually shift this balance in our lifestyle. That ought to be the starting point.

Having a Patron

What can we do in order to slack off?

My opinion is that we should have "patrons."

In actuality, a human being isn't a singular entity. We cannot exist unless we are part of a collective entity made up of many.

A patron doesn't just mean someone who provides money. Just as there are patrons of money, there are also patrons of knowledge, patrons of play and patrons of food. In this way, what you aren't able to provide for on your own, you can do by adding someone else to your collective entity. If you take a look at your own body, it's obvious. I have a brain, but I also have a mouth, ears, a nose and a stomach. I even have excrements. They all make up the unified body known as me and each has their own function. My own body is my best teacher. When you move with the sense that you make up a body inside of society, a very natural way of "living" is achieved.

I have countless numbers of patrons. "I" am made up of meeting, drinking, opening up to, and talking about problems with them.

For example, Ryō Isobe is my patron of music and play. Since meeting Ryō Isobe, my symptoms of manic depression have eased. Ataru Sasaki is my patron of philosophy. Shinichi Nakazawa is my patron of knowledge. Kageo Umeyama is my patron of editing. Naoki Ishikawa is my patron of action. Ryūji Fujimura is my patron of architecture.

Intellect especially needs its patrons. Do not overlook the genius beside you.

I guess that makes my wife my patron of "livelihood."

I'm hoping to be your patron of "living."

I leave whatever I'm able to in the hands of the geniuses around me. In turn, I fully trust them. I live according to them in their area of specialty. If you can add yourself into a collective entity like this, you can start living at ease. And then I can be aware that my mission is what I need to focus on.

There's no need for it to be a strong and tight community. It can just be friends. But, you should keep in mind what "Ministers" each of them are. Basically, you cooperate with each other and choose "living" as if it's a human body.

All of my patrons of money live abroad. Jack Adelaar, the lawyer from Vancouver, and present mayor of Bowen Island, was the first to buy my drawing. He also quickly bought the drawing series I started later on. I do not belong to a gallery. I find all my patrons without belonging to a gallery. The person who links me to all my patrons of money is Makiko Hara, my

patron of personal relations. Makiko is a gallery curator in Vancouver, who saw potential in me for contemporary arts when I was merely 21 years old, and is now also the new government's Minister of Connections.

3. How to Use the Lens of Despair

Depression as a Starting Point

As I have mentioned before, when I'm in depression, I feel totally hopeless. People around me laugh and wonder what I'm getting so serious over, but for me, I fall into desperation. Despair for the people who lost their lives during the disaster, for those who lost their loved ones, and for those who didn't lose anyone yet still lost their homes. Despair over the current state of society, over rubbish politics, and over the fact that so many talented individuals are working corporate jobs instead of carrying out the *works* that they should be focusing on.

At the same time, I turn on blaming myself, saying "Look at yourself before agonizing over others! You call yourself an architect but you haven't even built a house. You're an author but you don't read books, and you haven't received any awards. You call yourself an artist but you hate going to opening nights! When it comes down to it, you're just an arrogant perverse fool! You end up depressed and you even lose your money!"

Eventually I declare that my life is not worth living, and begin to think, "then might as well just die." When I'm in depression, my wife comes home every day worried that she might find me on the ground in front of our apartment. I cannot apologize to her enough.

Since I'm unable to do anything, my hands are completely idle at home. But since the only thing to come my way is the thought of suicide, it's quite exhausting. And with all of that gravity weighing down on me, I use my free time to reboot my thinking process. When my period of depression comes to an end, I am able to realize that the thinking process it gave birth to ends up becoming the guideline and text-book for my next move. At the time, however, I am desperate. I'm "thinking" for the sake of not dying.

This period actually started in August of 2011 and lasted for four months. The one before that in 2008 lasted for a whole year. When I'm down for one year I can fly for the next two. Based on this calculation, the next flight should last about eight months. It seems as though I can hold off until the summer of 2012. In which case, I make my schedule up until

then. Basically, instead of looking at a year-long calendar, I renew my life plan using my physical self as the starting point.

The Waking of the Lens of Despair

To say that I like having suicidal thoughts would be a misleading choice of words, but when I'm in that kind of hopeless condition, I interpret it not as *losing* all hope, but rather as *abandoning* all hope. This way, the state becomes self-initiated. Well, it may just be a play on words, but when you do this, what appears is an objective to the condition. It now is a path you've deliberately chosen to take.

When I lose hope, I go to the library. The Metropolitan Central Library in Hiroo was where I'd go in Tokyo. Now I visit the Kumamoto Prefectural Library. I read into things like art history and follow it all the way from Ancient Egyptian times. When I do this, interesting things happen. The distinction, between art created for social change, and pieces of entertainment made to meet the expectation of others, becomes completely apparent to the eye. And also whether a drawing on a wall is just a scribble, or an artistic piece containing a deeper spatial construct.

When my lens of despair—my hopeless perspective during depression—starts to zoom into focus, nearly everything in the world turns grey. Of course this is simply a symptom of depression—just a malfunctioning of Area 25[*] in the brain. Because of this I am no longer moved by anything. People call this a disorder. Yet thanks to that, when I lay my eyes on something genuinely astonishing, my lens of despair, like a computer, reacts so precisely, without the slightest hint of a glitch.

Wishing to die. Being in despair. These conditions, in fact, are strengths. Yet they aren't strengths for bringing about action. It's a form of strength that sort of turns you into a giant eye. In other words, instead of forming actions, you enter into a world of deep observation. You'd be able to tell at a glance the difference between art and design work—between self-expression and social realization. And then, like in the *Wizard of Oz*, a yellow brick road appears vividly in front of you.

So perhaps I will go on living with thoughts of suicide until I die of old age.

My suicidal wish has yet to be named. I would like to give a name to this unidentified mysterious strength someday.

Giving names; this is one of my *works* as well.

[*] Brodmann Area 25 (BA25) is an area in the cerebral cortex of the brain. Studies have shown that hyperactivity of this region plays an important role in major depression.

I therefore feel that people living without suicidal thoughts, or people who have had them in the past but have alleviated it using medication and are now able to tolerate working at companies, are wasting this potential. Losing that blowfish poison-like experience would be hard for me. I mean, that time right there is the only time that you can really think about "what it means to live."

When You Want to Die, Observe

The new government—as opposed to the current government—is determined at decreasing the number of suicides. "Zero suicide" is the pillar of the new government's policies. A few friends of mine have also lost their lives in this way. People decide that there's something wrong with getting depressed and end up not facing it all together. That's why we end up with people who can only carry out politics in a dreary flavor-less way. But truth be told, people have flavor, and we make unique colorful sounds.

I only look at the flavor in people. "What flavor is this person? How would his/her flavor suddenly change if I were to sprinkle a pinch of black pepper? Would this person taste better raw, grilled or boiled?" Let's do some cooking! The ingredients cannot cook themselves. Others must. That's human relationship.

That's why you—as an ingredient—shouldn't hide your own flavor. If you are having suicidal thoughts, you might as well say that you do. Of course, it's embarrassing, to come out and expose my state of depression to people and all. But hey, that's my flavor. My readers are therefore able to cook me in their own way. They offer me words of kindness, work, and sometimes, even money.

So, when you're having thoughts of suicide, how about using that lens to take a good hard look at society and seriously think over what you can do to change it. If anything, it's an excellent way to kill time. Since you're depressed, you have lots of time. And it doesn't cost money. Let's do things that do not cost money. Let's at least be able to think of ways to get a grasp on the minimal amount of money we need.

The lens of despair will give you a strict and critical eye. The satisfaction that you were able to have in saying you like design work will change into a sole interest in "art" that contains deep space and incites revolution in the thinking process. That is your chance. Don't feel that you need to take notes, just look. That's where it starts.

People kill themselves because they try to take action when they want to die. The lens of despair will teach you that money serves no purpose.

The act of thinking costs zero yen. Thanks to this, I don't spend money on having fun. Basically I'm aware that you don't actually need money in order to live. I am also aware, however that making that a reality, of course, will take some time.

When I'm feeling like I want to die, I conclude, "I am Sen no Rikyū*." I do nothing. Just as he found "Wabi-sabi†" in the rust [sabi] of old metal, all I do is observe. How could I miss this opportunity! The lens of despair does not just pop up during any old phase of life—it only appears when you're right at the edge, at the verge of suicide.

When I want to die, I search for art instead of creating it. Every doctor has told me that it is due to the symptoms of depression, that I am no longer driven to do anything, nor moved by what I see. But I view it differently. If you have no drive to do anything, then that means you shouldn't act. If you are not moved, it means that your critical eye is tuned to such great levels of precision.

So instead of saying that you're depressed, why not call it Sen no Rikyū syndrome? You may just smell the wafts of a new lifestyle by nonchalantly saying, "I'm kind of feeling a bit Sen no Rikyū-ish today."

Even with that said, what is there to do about this immense number of suicides. I mean, 30,000 a year is simply absurd. I suspect that this has a deep connection with art.

Make a Layer

When you use your lens of despair to spectate on your own "life," on the "art" born throughout history up until now, and on this society you are included in, you realize that the layers mix amongst each other in a variety of aspects.

During a manic state—a feeling similar to being in love—you are able to create many layers. You become aware of many good things, and you can encounter things like instinctive interests that you didn't even know you had.

You then take a good look at these layered structures of your mentality and observe them when you are in depression. You will find that there are many intersecting points, just like a *Minakata Mandala*. This then becomes a hint in manifesting your own mission.

In this way, many intersections form inside the concept city within your

* Sen no Rikyū was a legendary philosopher/tea master from the 16th century known for redefining the tea ceremony.
† Wabi-sabi is a Japanese comprehensive worldview or aesthetic centered on the acceptance of transience and imperfection.

consciousness. Just as we understand from the cities we live in, people gather at intersections. Intersections become places unlike regular streets, possessing a certain energy.

When I think like this, the layers that do not intersect with others end up reminding me of the back alleys in India that I grew to like for their peculiar textures. I adventure through the city in my mind like this. It's a very enjoyable task. The more you do it, the more it comes at you with a three-dimensional and spatial reality.

The lens of despair, as you can see, has the ability to dissect and analyze your own concept city.

It promptly awakens the feelings that were neglected in your subconscious, and can edit, repair, and reconnect them. There's really no such thing as a bad time in terms of the human mind.

Properly analyze the phenomena around you in high resolution, and you will find that they always function as helpful suggestions to continue living.

If you don't do this properly, then you will easily believe what other people say. If you compromise and tell yourself that's all you amount to, then you become subjected to "isms." You end up substituting your principle of living. Capitalism, communism, academic elitism, monetarism, common sense-ism—you can make anything into an "ism."

This doesn't involve any thinking. You end up living a subconscious and automated life that is not your own.

"*i-zoom* instead of *ism*."

That's what I say. I substitute capitalism with capitali-zoom. Instead of falling into a capitalistic thinking, it is the act of consciously thinking about what capitalism really is. In other words, it is the act of magnifying the resolution, as if you were "zooming" in on an image in Photoshop. By doing this, you give birth to "doubt" and the "question" of "why," as opposed to being sucked into the principles contained in the isms.

Let's be done with this ism-skism game. From now on, it's "i-zoom." Carefully observe, while magnifying the resolution on the situation you are placed in. But look at it abstractly at the same time, taking it to the realms of conceptual art. Confront this concrete living using abstract conceptual thinking.

Pay attention to words. Pay attention to certain events. And then understand their use and the meaning spoken of in groups within that singular layer, and then defrost and translate them into your own personal layer. An abstract thinking process will be needed for this. However, that

alone will not make it permanent. The key to doing this is in your hands.

This isn't difficult at all. For example, you may have a movie poster on your wall, Minoru Furuya's comic series *Shigatera* in a row next to a tasteful selection of philosophy books on your shelf, and vintage clothing on the rack next to your waiter's uniform. You may display things of various tastes, some embarrassing and others refined, together with other things you've liked since you were a kid. Yes, that right there, that is your layer!

Your layer is made up of all the things you already like. Now that you are feeling depressed and down in the dumps, this is a chance for you to observe your own layer (your room) to confirm your attitude from square one.

Whenever I get stuck, I go back to layer-creating.

People may accuse me of decorating concepts with convincing words.

But what I have come to realize from experience is that that very act of attempting things is in fact already an attitude, and that at a glance it may seem like a waste of time, since it is not making any money, however, the process itself most definitely gets across to others. Even when you're stuck and despaired, curled up in your blankets, the trading in Attitude Economics continues to occur.

At my high school graduation, the principal had this to say:

"Petty waste is nothing but a waste, but grandiose waste becomes a big asset."

Now let's happily get to work putting this grandiose non-money-making waste into practice.

FINAL CHAPTER

And Now, to the Zero Yen Revolution

Zero Public

WE HAVE finally come to the last chapter of the book. To close, I would like to write about the upcoming policies of the new government.

First of all, we will proceed with what we have been doing up until now. We will continue the Zero Yen School Camp to temporarily evacuate children from Fukushima during extended school breaks. We decided to execute the camp twice in 2012, in the spring and in the summer. We have to gradually increase the scale or there isn't a point in doing it. Recently (late March, 2012), we were successful in inviting the children again for a spring camp that went off without a hitch.

This time, something unforeseeable happened. Our plan, that NPO representative Mr. Uemura and I went ahead with last time after gathering funds ourselves, was now lucky enough to receive the cooperation of a few municipalities this year. We were actually able to receive partial financial support.

This is new potential. First, the residents propose ideas for policies and actualize them through their own efforts. And then by showing that to the administration, we convince them to implement it as local government policy. I don't think of the administration as an enemy at all. We simply decided to act because they wouldn't. I have the feeling that we may be embarking on a new way of creating public works.

Furthermore, with this plan, I have focused solely on gathering funds and left the rest to the younger generation. It's no longer an action of my own doing. Kumamoto citizens are getting increasingly more involved. There also is a blossoming potential for a new community. It could also be a new methodology for the education system.

The policy that I want to manifest next is what I've named Zero Public.

That entails making safe zones all across Japan that follow the 25th Amendment of the Japanese Constitution. This is my mission. What this means is creating areas in which people can live even without money. I will design homes as public structures that people can live in for zero yen.

Rather than an "economic free zone," I have decided to call it a "Zero Yen Zone." The Zero Yen Zone is nothing novel. If you read the Japanese Constitution thoroughly this is very obvious. The national policies now, that say those who do not earn money might as well die off, are completely unconstitutional. People have the right to live a joyous life without having to earn money. That's why I, with the cooperation of many citizens, want to make it a new governmental policy, and a chance to reconsider what public really is.

The Zero Yen Zone. It's easily said and obviously hard to accomplish. However, it's not impossible either. That's because, as I have previously mentioned, Japan is overflowing with an unbelievable amount of surplus "stuff." Yet the nation and corporations try to make you think that there isn't enough. That's because stuff won't sell if they don't. Even in the United States, where sub-prime loans are causing havoc and a surplus of homes, they are knocking them down in order to fabricate stories on the residential situation.

It's truly a state of stupidity. There's no way a nation can be stable with policies like that. A labor dynamic that practically forces 35-year loans is basically a slave system. You become stuck, chained to the land. Still you must work in order to pay back your debts. Even if we're aware of the radioactive debris piling on the ground, we cannot quit our jobs due to living expenses and loan payments.

How absurd. The act of living is misunderstood.

The new government intends to insert a scalpel into the very core of this labor issue: the earning of money.

More than likely, this is a topic that you are very interested in as well.

"People go bad unless they work." "Money has some importance after all." I can understand how people may think this way, but we must revise this completely irrational way of developing an economy based on debt carried by citizens for their purchasing of homes, cars, etc..

Don't you think it's time for us to take action? How about we express in our attitude the things that we take to be wrong? This is also a battle. It is an emancipation movement from the harnesses of labor and money. Sad to say, yet alas, we are slaves. We must escape this state.

It is a battle for those reasons. But I am of a nonviolent and noncompliant mentality—with a zero yen mentality on top of that.

Zero Public is a Zero Yen Revolution. It is carried out without involving violence in any way whatsoever. Zero Yen is our strategy and our offensive. It's a revolution awoken by thinking.

Let's start working together. This policy requires everyone's efforts.

A Precise Image of Zero Yen Zone

So what would a Zero Yen Zone look like? Let's begin to think in more specific terms. But before we get into that, is it even possible to live off of zero yen here in Japan?

All of you who have read this book up until now will know that it is possible. In other words, the street dwellers have already actualized the Zero Yen Zone. If you go to the Tama riverbank, you can see that residing on this nationally owned land is still tolerated. The rent is zero yen there. It's even possible to make a home for zero yen here if you use the "fruits of the city." People like the Robinson Crusoe of Tama River are one step ahead and have already made the Zero Yen Zone a reality.

That's why I think that *a revolution has already begun.*

Of course, it is a barely legal act supported only by the right to survival, and if the state was to really act, then the homes would be instantly dismantled and removed. However, I want you to keep in mind that they still manage to exist under current situations. I would like you to have the awareness that this is not something preposterous.

Would it be possible to actualize this Zero Yen Zone policy as public spaces that anyone could create and use? That's what I've been wondering. This is basically what I've been dreaming of ever since realizing my mission.

If living expenses are zero, then you are no longer chained down by labor. It will allow you to choose your own life. People who don't want to do anything won't have to. But no one is like that. Out of boredom, people will yearn for action. Just like the gardener in Nakano did, they will try to make parks even without monetary reasons. Being emancipated from labor should prove to be a short cut for actualizing missions. That's what I think.

The New Government's Strategy to Increase Territory

First, in order to make the Zero Yen Zones, I created a website called zero-public.com. Please take a look at the following picture—a map of Japan with a number of signposts.

These locations labeled on the map are all territories of the new government. They are public lands that everyone can freely use. However, I don't want you to misunderstand. This isn't done on the current government's layer, but rather on the new government's. In other words, there's

The New Government's territory expansion project. (http://www.zero-public.com/)

no ownership. You cannot buy or sell. Only the usage of the land is permitted. It's land for everyone to use cooperatively as public space.

And what kind of land is it?

As previously mentioned, the land indicated here either doesn't belong to anyone, or is unclaimed. Since we don't know whose it is, we shall use it as land for the new government. Finding land with an unknown owner, however, is in fact quite difficult.

My true objective is to turn all of the unused land into public land of the new government.

In other words, since we are not going to use the land for "speculative transactions" or build "immobiliers" by burying concrete foundations, we are asking for the usage rights of all unused lands. What I want to attempt with Zero Public is a methodology for converting the usage of these unused pieces of land, houses and vegetable gardens.

If you take a look at the website, it says "the area of territory" on the top right. As of April 2012, 1,426 m² have been offered. People have offered this much unused land. People who have extra land in fact wish for it to be utilized effectively. When expressed as a policy like this, people who can offer and people who are in need can now actualize a smooth trade.

This is another form of new economy. And since it exists on a different layer than where the buying and selling of land happens, there's no need for anyone to worry unnecessarily. There's really no need to make contracts or anything either. We simply utilize unused land. This makes for carefree open-hearted offering of land.

If one added up the area of empty houses and uncultivated farmlands in Japan, the result would be immense. But even then, under our current economy, houses are continuously being built, and land is bought and sold at outrageous prices. Can you see why a place like Tokyo, a centralized concentrated place, has been created? If it were all decentralized, the land value of Tokyo would go down. If that happened, everything would collapse. The truth behind how false the real estate economy is will be exposed. For this purpose, the nation desperately continues to fabricate the

Tokyo Illusion. And despite this illusion of high land value, the masses are running about worked up over labor in order to purchase these lands and houses.

Let's immediately put a stop to this cycle. The fact is, land is in surplus.

Zero Food Expenses

On these lands that have been offered for zero yen, people can of course live a life of zero cost, as the name Zero Yen Zone suggests. Many fruit trees are planted there. Native wild plants as well. My intention is not to start farming on these lands. The objective is for these plants to freely grow. That way there will be no need for labor. All of these plants have been eaten since ancient times, without even the need for fire. If you get hungry you only have to pick and eat.

I would like to give many different fruits and vegetables from all over the world a try. A Brazilian friend of mine is always eating bananas saying that they are the simplest, cheapest, and most nutritious meal.

Those who don't want to eat them every day don't have to.

But if you want to live a life of zero food expenses, you can. There will be no need for fire or electricity. You can consume it as it is. Therefore, meals wouldn't even take up time. You can further focus and concentrate on your missions.

Zero food expenses can be made possible without the act of farming by simply creating a space where we allow plants and vegetables to freely grow in their natural forms. In doing that we would not "harvest" in the way that agriculture goes about doing today. Rather than picking everything, we will eat moderately and leave enough for others as well. A humanitarian approach of this sort will be desired.

At the same time, due to the fact that there will be fruit and vegetables planted for free growth, it will be an opportunity for seed preservation. Once TPP [Trans-Pacific Partnership] is implemented, then our seeds will end up being controlled on a global level. So also, in order to prevent this from happening, it is important for us to preserve our seeds. My friend Goose in Utrecht is one of the world's leading seed bankers, and collects all types of seeds from around the world. I would like for the Zero Yen Zones, with the help of our Ministers of Seeds for the New Government, to act as a seed bank as well. The seed banks are beneficial to the children of the future.

Zero Housing Construction Expenses

Next is the housing.

Of course, inside Zero Yen Zones, Mobile Houses will be built. The building of these Mobile Houses will be done by those who will live in them. It is a task that anybody can do within three days at the most. Doing this, in return, will become a survival skill for the individual, freeing two birds with one stone. It will serve as a form of education, teaching you how to build your own house. The Mobile House will act as an educational facility, a place to achieve survival skills, and also as a shelter to protect you. The ability to build your own home, for humans in ancient times, was a necessary skill to have, and possibly the most important of all. This will be the revival of this very fundamental survival skill.

Because they are Mobile Houses, a concrete foundation is of course not needed. And because they are "mobiliers" it will not be a nuisance to the owners of the land. If the owner wants to use the land, all you have to do is move it to the next location. If you were to leave the Zero Yen Zone, you can either give the Mobile House to somebody or you can deconstruct it and leave the parts for somebody's future construction. This proves that the houses can be recyclable. And they are inexpensive. Of course, within the Zero Yen Zone, I intend to manifest zero costs for construction.

How do we actualize this?

I have appointed my best friend, who is the head of a leading industrial waste disposal company in Kumamoto, to be the Minister of Recycling for the New Government. This is because he, questioning the current state where people are paying money to dispose of construction waste, started stocking these scraps according to their components. This holds great potential.

Currently construction waste is destined to be thrown away unless it is, for example, a pricey antique wooden crossbeam. But lumber, unlike newer materials, can be used for at least double the number of years that the tree was alive. They are valuable resources that you just cannot refer to as trash. The new government will reuse them as public assets, utilizing them

A model of a Zero Yen Zone with rows of Mobile Houses

as recycled material for the Mobile Houses.

I am planning to make a facility much like a hardware store where materials will be separated by their components. It will be a zero yen hardware store.

Everything will be zero yen and you can build using these materials. Joy and excitement on the faces of children will be inevitable.

Energy Policy

I would like to bring back wells as water supplies. It's what humans have done up until now. Why are we subjected to drinking chlorine filled tap water, and having to pay for it nonetheless? There are many natural springs in Kumamoto. Needless to say, very dangerous pesticides are in use, so poisons have seeped into the soil. Research and investigation will be needed for this one. Humans are such foolish beings. They spread even poison if it serves their own convenience. Human beings have been scattering poisons long before the explosion of the Fukushima Dai'ichi nuclear power plant.

I want to also give thought to energy consumption.

I intend to make 12-volt batteries the basic format of electricity in the Zero Yen Zones. Of course people are free to choose 100 volts if they prefer, but when people find out how convenient a 12-volt format is, who'd want to pay electricity bills just to use the 100-volt format?

Mega solar power plants, quite frankly, are the pinnacle of stupidity[*]. Those things are absurd. I want to follow in the footsteps of the street dwellers and apply the skills that they taught me. Starting with small solar panels, I will have the residents understand just the right amount of consumption that they need. There probably won't be a need for TV. I don't think anybody takes TV seriously anymore. So we will construct a 12-volt electrical environment that will allow us to fully use our computers. That way our electricity bills will of course be zero yen.

In the midst of those thoughts, I met a man at a bar one day, who told me he was interested in my new government. He was a dentist. But he had another side to him. He was also an independent researcher for sustainable energy. Finding potential in rapeseed and tempura oil, he had thought up a unique filtering system and had even patented it. It turns out he was also an inventor. I immediately appointed him as the Minister of Energy for the New Government.

He says, "if you were to plant broccolini on a one hectare area (100 x

[*] Sakaguchi has mentioned in a speech that regardless of the method, generating electricity in power plants is counterintuitive and the "wrong approach."

100 m), that is comparable to a family owning their own private oil well."

An unbelievable find! Diesel engines can run on rapeseed oil. Which means that we will no longer need fossil fuel. Of course CO_2 emissions won't be a factor either. On top of that, Japan is full of uncultivated farmland. Since broccolini grows in the wild, there will be no issue in taking care of them. They will bloom every year without fail. There isn't even a need for labor. I thought this find to be very fascinating.

The new government should one day build a rapeseed oil factory. In the spring the yellow flowers will flourish, and may even end up becoming an attraction. In this manner everything is possible for us to do with zero yen, even when it comes to energy. Of course this is at the mercy of the environment. We really must thank the environment. This isn't the time for us to sit around and say we have to be kind to the planet. The planet is already very kind to us.

Keep on Moving

After having people offer their extra land all across the country and building a new public Zero Yen Zone, I would next like to work on carrying out trade. To me, actualizing zero yen living expenses is not the end of it. It is unconstitutional how expensive living costs currently are, and therefore I simply wanted to make a place to live without having to pay rent. Once we succeed in protecting our livelihood, we must then focus on completing our missions. We will then have time and we will be freed from labor. We will need to take action to better the current suppressed state of art and society.

For that, trade is necessary. We must make the Zero Yen Zone also a place where people with a variety of thoughts can gather and interact.

Therefore after these Zero Yen Zones have been completed, the new government would like to encourage movement. Human beings originally are hunters and gatherers, and movement will surely energize our thinking process. It also is a very rational and logical methodology. It has only been a little over a year since I relocated to Kumamoto, yet moving through various prefectures and countries such as Kumamoto, Canada, and other regions has had a very positive affect on my mental wellbeing. And what's more, even my income has doubled. Not moving shouldn't be an option. Let's keep on moving and keep on trading.

Although, travel expenses are high in Japan. The price to ride the bullet train is outrageous and it's cheaper to fly abroad than it is domestically. Travel expense is a limiting factor. Society is currently structured to make

it difficult for us to travel. I feel that this is also linked to the current labor environment of Japan.

Then I thought about how I used to hitchhike since I was 18 years old. I have even gone from Kumamoto all the way to Sapporo*. In other words, I'm a professional at getting around for zero yen.

I am now in hopes of systemizing this. Take the driving distance and driving time of those who have cars, collect them, edit and make a schedule diagram like that of a train and have people keep on moving, and sharing rides. I want to make a new form of public transportation based on hitchhiking. It may be unreasonable at this stage but I would like to keep it in mind.

These are my thoughts regarding how Zero Yen Zones should be. But of course they are only my ideas. There must be debates in order to decide on policies.

Something like a national assembly is what we need now.

Obtaining a Congress for Zero Yen

I continue to fly around to many places, all over Japan and the world, giving talks—at times even without compensation—about Zero Yen Zones and other topics. Doing it for no compensation is a given. Somebody who wants to make a change regardless of salary—that's who should be Prime Minister.

Recently, I was invited by a bank to give a talk. I'm one who has been criticizing the 35-year home loans the banks offer. Yet they decided to send me an invitation. This in itself is a very interesting step for society to take. The banks and home builders have already realized. They are aware, that the way in which houses are sold, that this economy built on the backs of loan carrying citizens, is all wrong.

And so, the other day, I went to Tokyo Midtown in Roppongi. We talked in the open space that the bank had set up on the seventh floor. The talk was a success and it seemed that the bank attendees enjoyed themselves as well. It was an amazing meeting. I could see a ray of hope of the future.

After the talk came to an end and I was talking to a bank representative, the manager came up and said:

"Excuse me, how do I go about registering the right to use our open space here as territory of the new government?"

I thought it was a joke and laughed it off at first, but it seemed he said it in all seriousness.

* Approximately 2,200 km.

And that is how the new government was able to obtain a whole floor—albeit just the right to use—of a stylish building in Roppongi.

That is when I decided.

"This space will be the Congress of the New Government. That's bound to create trouble between the bank and the current government, so I shall call it a University. I will run it as a space to think and have debates regarding the future forms of the ideal public."

Upon immediately expressing this idea to the bank, they gladly gave permission, saying:

"Doing it under the name of the new government would prove troublesome, but the idea of thinking about public conditions is an idea we too share, so please feel free to use it."

As you can see, society is actually a very fun place. Everyone wants to cooperate if you present a bright and fun idea.

So, as of April 2012, we have begun our Congress at Tokyo Midtown. Once a month, participants of all licenses, ages and specialties gather to think about what Minister they can be, and move accordingly. They self-govern. With their very own hands, they create a public from zero.

I felt that this was the true appearance of an ideal Congress.

Forty-five people gathered for the first assembly, and an energetic discussion about how to manifest the Zero Yen Zones was carried out.

The Ever Expanding New Government

One day, I received a curious message. It was from Belgium, written in English. The content surprised me.

The Prime Minister of the "New Government of Belgium" had e-mailed, and since he was to come to Japan in the near future, he wanted to have a Heads of State Summit with the Prime Minister of the New Government of Japan, which would be me.

Belgium has experienced a period of time where there was no government at all. During that time, some of the young individuals had decided to make attempts at autonomous self governing. In their eyes, my new government was not something that was thought of as crazy, but rather, an entirely legitimate initiative.

During a conversation I had the other day with Todd Lester, an activist involved in the recent Occupy Wall Street demonstrations in New York, I physically experienced the energy and desire among young people today to self-govern and to build independent nations. He also showed his support for my new government, and told me he would like to act in unity.

Issues of nuclear power are not ones that concern Japan alone. It is an insane issue that is happening all over the world. We are now standing on the brink of an era where we must seriously and duly think about what we can do for the future, without being concerned over profit and loss.

February 2012, the three new models of Mobile Houses that I exhibited at the Kanagawa Art Theater in Yokohama were instantly sold. The designs of which I handed out free copies of also vanished in no time. They used to get made fun of, but Mobile Houses are no longer a joke.

I believe that Mobile Houses can allow us to see one form of an "answer" in response to the many social issues that I process in my thinking: issues of land ownership, home loans and rent—not to mention the issue of modern slavery known as labor.

This exhibition was held at an event called TPAM (Tokyo Performing Arts Market), that introduces Japanese performance art to the world. The European directors saw what I do as a type of performance art. They took it as the theaterization of the mere acts of everyday life. It was a very interesting point of view.

In 2012, I have been invited to be in large festivals in Seoul, South Korea in July, Slovenia in August, Switzerland in September and in Berlin, Germany for October. All to exhibit Mobile Houses. I felt that the movement of the new government is needed all over the world, not just in Japan. I want to build Zero Yen Zones throughout the world as well.

Just Doing It

My life continues to change mysteriously but my roots will forever be the adventure in the sewer. Instead of buying or changing something, you can turn the world around by thought alone. Increase the way in which the world exists. I am confident that my mentality of self-governing will continue on.

I am sure there will be a lot of hardships.

But I don't mind. I will keep pressing on.

Luckily, nobody takes me for a strange person anymore. There are gifted minds all over the world with similar thoughts and visions. There are excited individuals who are more focused on expanding society rather than their own monetary gain. Even if we have yet to encounter each other, we are still amazing friends who will be able to understand each other instantly.

I want to fight along side them. And do it for zero yen at that.

The state of politics will change.

Local autonomy and self-governance will become the main asset of society.

I am now sure of it.

I have come to truly see that an independent nation has blossomed inside the mentality of each one of us.

This is where it begins.

I plan to put my heart into it and tackle it all with courage, cooperating with friends, and at times doing stupid things while laughing.

Build your own Independent Nation.

To think about this is to be unashamed to seriously think about "what it means to live."

Let us "think." And let us expand society.

I want to overcome whatever fear may come, and yearn to continuously "think" as I conquer my life.

That is my mission.

EPILOGUE

We are Not Alone

To think about a way of living, about homes, and about my own life all from scratch is what I consider to be my "art." It is to think about these specific things, and to attempt to know how much it is that I require, through my own experiences. This gives birth to "technique." This newborn "technique" is not for making money. It becomes one's "gift" offered to the people around.

Zero Yen Zones exist in order to bring this into realization. Having this kind of place should not only prove as a safety net for each person, but also as the starting point for each person's philosophy.

Humans can never possess land. Any elementary school student could tell you that.

But with age we lose our ability to think clearly, and we end up with misunderstandings.

And to make matters worse, we carry on while being fully aware of our own misunderstandings.

Shall we not come to terms with this, and start acting upon it?

This is how my new government started. Just how far can you go, by yourself? For me, there's no way I will let myself die without knowing this.

The birth of my own daughter surely played a significant role as well. What must I teach and pass on to this future talent?

I couldn't just say to her, "*Shikata ga naî*."

I concluded that it was better to take action, even if it meant making mistakes.

And now it has been nearly a year since starting the new government.

I can say with confidence that it was not a mistake.

Because I was able to find my mission.

Wanting to contribute their talent to society, people will make attempts to gradually distance themselves from mundane labor. Zero Yen Zones will become a device for the sake of this. They will allow people to truly realize, that thinking about how homes exist, is indeed, economics itself.

* *Shikata ga nai* is a common saying in Japanese which literally translates to "no options available," but is used more commonly to express a sense of resignation, such as "oh well", or "nothing you can do about it."

And then they will take action in building their own new economy.

This will give birth to a new community; shaped by the trading of each person's talents and not by the exchange of money.

It will be a type of social network that doesn't necessarily live together, but continues to move and trade with a good grasp of each other's differences.

The Internet is just one tool.

The real intent is for people to directly meet one another.

So walk. No matter what, just keep walking.

Meet people.

Don't ever let your thoughts stall on you, when it comes to the things you are not convinced of. Think! Expand!

Take your complexly layered mental city and expand it into a physical three-dimensional space.

That is "living."

You must never stop thinking.

That is our energy source.

Exploding won't help. Instead, continue connecting with a controlled thinking process.

Self-govern as if it were art.

We are not alone. Rather, each human is a single atom. Determining what role it is that you possess is at the same time caring for society—a collective structure much like the human body.

With the mindset that you are a single cell, connect with others. Then, create one huge body and attempt to move it organically.

That is the kind of society I want to create.

That is the kind of human I want to be.

That is the kind of life I want to fulfill.

It is time.

Everyone return to your post and start moving.

We shall meet again, somewhere, somehow.

POST SCRIPT

I AM currently visiting Singapore. Invited by the Singaporean Minister of the New Government, I came and gave a lecture. Not only Singaporeans, but Japanese, Italians, Spanish, Australians and people from various other countries gathered from afar. Next, I will be holding a symposium on tiny "Micro-houses" in Jakarta. My Mobile House has now started taking flight around the world.

My documentary film *How to Make a Mobile House* will also be released in June.

My fieldwork on the street dwellers became the basis of a movie, and has now become the film *My House* directed by Yukihiko Tsutsumi.

My works had hardly seen the light of sun, yet ten years later they have started flying around the world at an amazing speed. I am ecstatic! At the same time I feel a sense of responsibility that there will be consequences if I don't carry through with this seriously.

I'm glad I patiently kept at it until now. If you keep at it over time and never give up, your attitude is sure to reach the world. You then become a catalyst for social change.

After starting the new government in May of 2011, I spent the next three months bustling about without sleep trying to get ready for the evacuation plan and the temporary relocation for Fukushima's children; the zero yen summer camp in Kumamoto. Then in August, perhaps due to physical overexertion, just as I was beginning to think that this sudden idea I had to self-govern may hold potential, I hit a wall of depression for the first time in two years. After that, for about four months, without being able to write a single page, I was curled up in bed from midday full of regret for this ridiculous "new government" I founded. My folks took me to a mental hospital. I didn't think I was insane, but people around me were starting to wonder if building a new government was perhaps taking it a bit too far.

This book is based on my thinking process during the time I was in my state of depression. I was of course unable to write a single line at the time, but I could see a light at the end of all my thinking, and because of it I was

able to walk outside for the first time in four months.

After that I began to write with a furious sense of concentration.

The platform I chose, naturally, was Twitter.

Every day I wrote nearly forty pages worth of writing. Since its launch, I have written about 1,500 pages and I continue to write more.

Twitter, as it is on the web, can obviously be read for zero yen.

I decided that this was alright. I simply wanted my writings to reach people.

My wish is to do works that are visible even to people who have no money. They are able to read them as long as they can access the internet.

I continued to write for zero yen.

One day, the man who would later become the editor of this book, Hōsei Kawaji of Kodansha, contacted me on making a book out of the writings I had been releasing for zero yen. I told him that I didn't know who would buy a book made up of writings already posted for free, and asked him if that was still okay, to which he replied, "of course." So I entrusted Kawaji and decided to make this book. I want to show my appreciation to Kawaji. I am confident that we were able to make a book that stands alone.

I still intend to take the liberty of sending out my writings into the world for zero yen.

This is my way of practicing Attitude Economy.

Although the book bears the slightly over exaggerated title of *Build Your Own Independent Nation*, I knew it couldn't be anything else but this, and had decided on it from the moment I got the go for the publication.

In this bewildering era, we may see the emergence of a society where each and every person lives in self-governance, mutually cooperating with one another. I do what little I can, and every day I feel the enormous powers of the human kind. I feel there are great new potentials for economics.

I wanted to contemplate on the true meaning of economics.

That was my intent and reason for writing this book.

Why don't we refine our "survival methods," trade and exchange them with others, and ultimately help expand this society, further and further.

I am really looking forward to what is to come.

Although we near the end, I would like to send my gratitude to the citizens of the new government who continue to send their council, criticism and advice to my Twitter page and all of my friends who have given me inspiration.

I have to thank my wife Fū, who continues to support me with this new government, no matter how crazy it all seems, and my daughter Ao who comforts me with, "you're perfectly normal Papa." You two have saved my life, literally. Thank you for always being the closest to me.

There isn't a doubt in my mind that something has already begun.

A revolution, is already happening.

<div style="text-align: right;">
April 9th, 2012

While tasting the southern winds of Singapore,

Kyōhei Sakaguchi
</div>

ABOUT THE AUTHOR

KYŌHEI SAKAGUSHI, born in Kumamoto City in 1978, is an artist who builds, writes, draws, dances, and sings. After graduating from the Department of Architecture at Waseda University in 2001, he published a photo book in 2004 titled *Zero Yen House*, documenting the homes of the so-called "homeless." In 2006, "Zero Yen House" exhibition was held at the Vancouver Art Gallery (Vancouver). In 2008, he published *Tokyo Zero Yen House, Zero Yen Living*, documenting Sumida riverside resident and master street-dweller Mr. Suzuki's approach to living. 2010 saw the publication of *Starting an Urban Hunting and Gathering Lifestyle from Zero*, teaching urban survival methods that utilize the "fruits of the city" instead of relying on money to live. In the same year Sakaguchi began constructing Mobile Houses—built free from the constraints of private land ownership—at a unit cost of 26,000 yen, and also opened "Zero Juku," a private school that charges zero tuition fees. In the aftermath of the 2011 earthquake and disaster, Sakaguchi established a "new government" in his hometown of Kumamoto, inaugurating himself as its first Prime Minister. Zero Center, the Prime Minister's official residence, took in children from disaster-stricken regions of Fukushima. *Build Your Own Independent Nation*, published in 2012, was widely read as the new government's declaration of independence, becoming a best-seller with over 60,000 copies purchased. An unplugged solo album, *Practice for a Revolution*, was released the same year, gathering over 600 fans to pack Shibuya's Sakura Hall. The "Sakaguchi Kyohei: New Government Exhibition" was held at The Watari Museum of Contemporary Art (Tokyo) in the same year. In 2013, Sakaguchi published the novel *Gennen Jidai*, and *Sakaguchi Kyohei's Manic Depressive Diary* which chronicles his trial and error method of coping with his bipolar syndrome. He was awarded the Takamasa Yoshizaka Award in the same year for his "activities that reexamine the fundamentals of living." Sakaguchi's 2015 album *Atarashii Hana* (new flower) attracted attention for his relaxed, almost bird-like song-writing style.

ABOUT THE TRANSLATOR

Corey Turpin, born in Pennsylvania 1985, is a translator, dancer, artist, and earthling. Moved to Japan at age of sixteen. University of Shizuoka graduate, Japanese literature major. Currently active in Japan's underground street dance scene while doing translation and art projects.

Kaz Egashira, born in Kyoto 1988, is a translator, musician, tree climber and vinyl addict. Was host and DJ of own radio show while attending University of Hawai'i. Currently causes currents in the Kansai region.